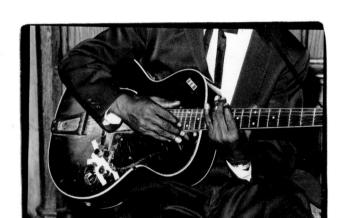

DATE DUE

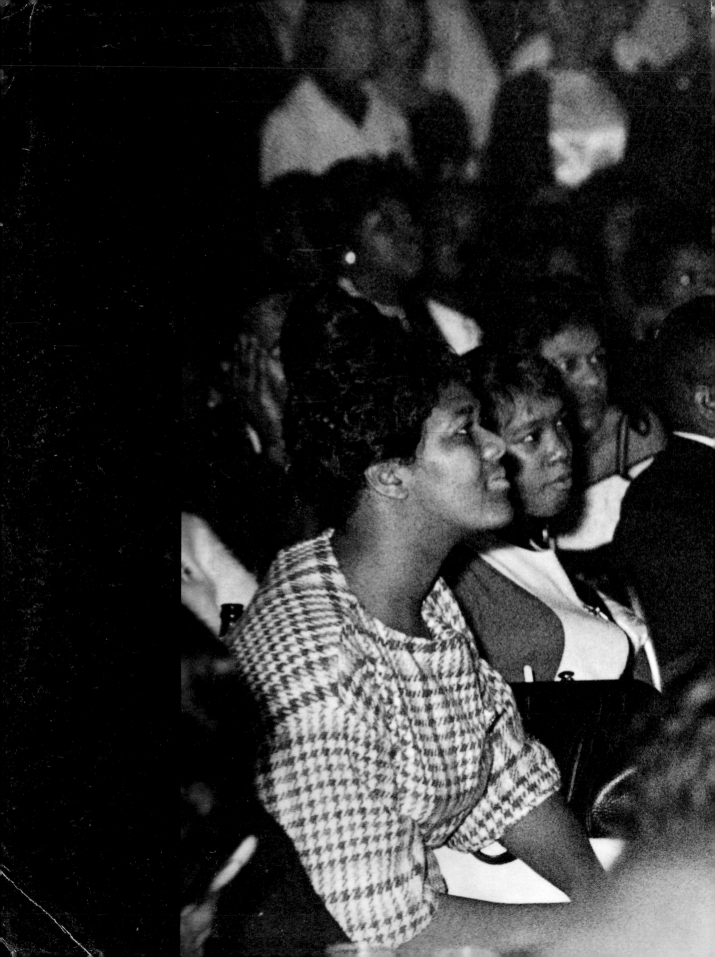

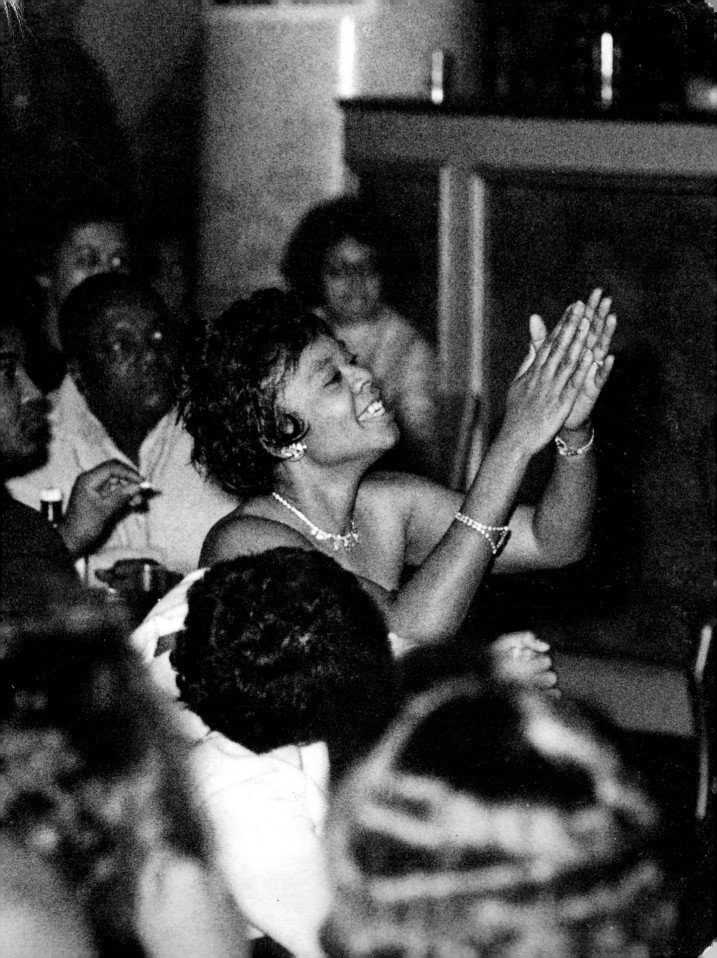

Chicago Blues

as seen from the inside

The Photographs of Raeburn Flerlage

Edited by Lisa Day

ECW PRESS

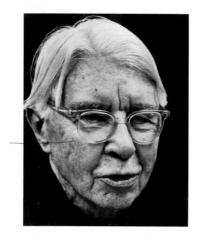

What are these dialects deep under the bones whereby the people of all ages and races far apart reach out and say the same clay is in all, bringing out men whose eyes search the earth and see no aliens anywhere, pronouncing across the barriers the peculiar word: "Brother"? —Carl Sandburg

Copyright © ECW PRESS, 2000

CANADIAN CATALOGUING IN PUBLICATION DATA

Flerlage, Raeburn
 Chicago blues : as seen from the inside : the photographs of Raeburn Flerlage
 Edited by Lisa Day

ISBN 1-55022-400-X

1. Blues musicians - Illinois - Chicago - Pictorial works. 2. Blues (Music) - Illinois - Chicago - 1961–1970 - Pictorial works. 3. Blues (Music) - Illinois - Chicago - 1971–1980 - Pictorial works. I. Title

ML3521.F53 2000 781.643'09773'11 C00-930438-X

Cover and text design by Tania Craan
Printed by Printcrafters

Distributed in Canada by General Distribution Services,
325 Humber Blvd., Etobicoke, Ontario M9W 7C3

Distributed in the United States by LPC Group
1436 West Randolph Street, Chicago, Illinois, U.S.A., 60607

Published by ECW PRESS
2120 Queen Street East, Suite 200,
Toronto, Ontario, M4E 1E2
www.ecw.ca/press

The publication of *Chicago Blues* has been generously supported by The Canada Council, the Ontario Arts Council, and the Government of Canada through the Book Publishing Industry Development Program. **Canadä**

Printed and bound in Canada.

In memory of Moe, Slim and Muddy.

This book is dedicated to Luise who brought it all together.

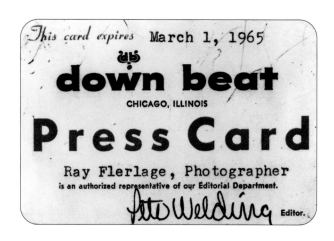

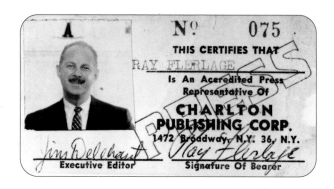

PREFACE

Although originally most blues singers appeared alone, the trend has been toward partnered or group performances. While many of the images in this book are of solo artists, the great bulk of them represent various multiples. Reaching almost the outer-limits of ridiculousness, the Lloyd Price/Slide Hampton band at the Regal in 1963 had a blues singer working on stage back-to-back with an arranger/conductor. Fortunately, nobody carried that urge toward overkill any further.

In producing this book, we followed the trend toward expansion. Although my wife, Luise, and I had plans for a book in various stages of discussion, it was only when Lisa Day entered the picture that the project really caught fire. And when the three of us finally met with Jack David of ECW Press, we started hurtling toward the inevitable conclusion—a book based on photos taken in Chicago of the major—and minor—blues artists who performed here during the '50s and '60s.

We had met Lisa Day almost by accident. The brilliant young film editor, known for her work in such projects as *Hail, Hail, Rock and Roll,* was working with Martin Scorsese on a documentary, *Nothing But The Blues:*

Eric Clapton's Roots in the Blues. Some of my shots were being considered to illustrate the role played by Chicago bluesmen in Clapton's background.

When Lisa ran across the club scenes—and particularly those taken at the Trianon Ballroom in the '60s with the dramatic spotlights cutting through the heavy clouds of smoke—she "flipped." "I never saw anything like it!" she said in a phone conversation. "It opened up a whole new world to me."

We kept in touch.

A few months later, Lisa came to Chicago carrying a ton of heavy gear. Over a three-day period she shot a 12-hour interview and a set of still photos of Luise and me that completely outclassed anything that had been done before.

We realized that Lisa was a dynamo, and when Jack David came down from Toronto to discuss a book based on my photos, we asked Lisa to join the conference.

Jack had a highly successful blues book on his hands with Sandra Tooze's *Muddy Waters: The Mojo Man,* in which some of my shots of Muddy were used. Jack was most interested in a book of blues photos with a strong emphasis on Chicago, which of course was "my thing" anyway.

Although she was up to her eyeballs in other projects, Lisa agreed to edit *Chicago Blues.* In the months ahead, whether she was in Paris, Athens, Milan, Boston, Portland, Chicago, Toronto, or *wherever,* she kept the project rolling. On one occasion in mid summer, during one of the infamous Chicago power blackouts, she worked for three days in a stifling hotel room with no air conditioning and no lights.

She used hand-held flashlights—but she got the work *done!*

And she discovered treasures in my photo archives that I myself had never really seen!

We also had a "guest performer." My friend Chuck Cowdery, with whom I had worked on *Blues Legends,* had repeatedly offered to help. He knew that my texts sometimes suffered from "overload" and felt he could apply his "pared-down" style to a reduction of the mass.

Working together, we threw out some of the ornate polysyllables and achieved the desired condensation. At last we had a TEXT!

Charles, my friend, how did I ever get so lucky! Thanks a million!

So! Did you think I'd never reach the end of this "brief" Preface? Well, all we have left is the main part—a salute to the one who made it all happen.

As you know, all the disparate elements of *anything* won't work unless you have a central force linking them together. In this case the central force was my wife, Luise. She assembled all the pieces and applied her wide areas of experience and brought them all together. She was able to offset some of my own shortcomings and idio-syncrasies to come up with "the best of everything."

My own notes covering more than 50 years of compendious reminiscences were written in indecipherable longhand. Luise was the only one who could read it. She transcribed these mountains of confusion into hard copy—a minor miracle!

If it weren't for the fact that the book is about the *Blues,* we could call it "Luise's Book"!

As it is, we close with a salute

To Luise!

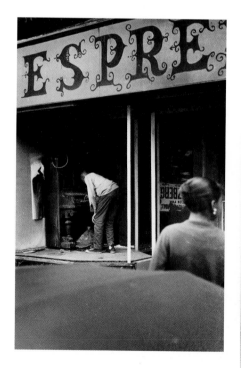
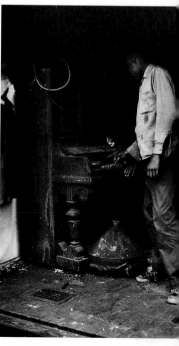

CONTENTS

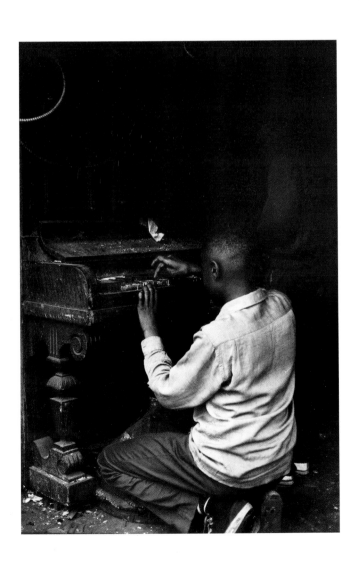

INTRODUCTION

BY WAY OF FAT SAM

Somewhere along the way, as I moved between Cincinnati and Chicago and back again, I picked up an obscure phrase that stuck in my mind. "By way of Fat Sam," as I understand it, is a folklorish description of a tortuous, circuitous and sometimes almost directionless meandering toward a place or a goal—hypothetical or otherwise. It's probably an accurate characterization of the serpentine route that led to this book (first planned in 1965).

Chicago Blues in the '60s was an event that needed to be documented. The urban electrified blues sound that originated in Chicago in the '50s and '60s led directly to rock and roll, and its influence can be heard in virtually every contemporary form of popular music. Chicago was home base for the era's most influential songwriters and performers: Muddy Waters, Howlin' Wolf, Little Walter, Willie Dixon, Little Brother Montgomery, Sunnyland Slim, Magic Sam and many other legendary names. The established Chicago photographers of the day were all busy with other projects, so it fell to a newcomer to capture this incredible musical epoch. As the only nominee, I was elected.

I had been kicking around on the fringes of the music business in Cincinnati and Chicago since 1939. I did promotional work for record stores, organizational promotion, concert reviews, music columns, lectures and magazine articles. When Moe Asch of Folkways Records gave me my first professional photographic assignment, to shoot Memphis Slim for an album cover, I already had many contacts in the music world. For that and a variety of other reasons I was a natural person to capture, in pictures, the major blues, jazz and folk artists of the era.

RECORD MAN

Records were an important part of my early life in Cincinnati. My parents played John McCormack, Marian Anderson ("Ave Maria") and Paul Robeson ("Old Man River"), while my paternal grandmother favored Caruso, Ponselle, Schipa and more McCormack.

After high school I attended the University of Cincinnati. One day, an English professor unexpectedly offered me a vast, out-dated library of 78 rpm classical albums: Beethoven, Brahms, Schubert. The collection included symphonies, concertos, string quartets and the unforgettable Schubert Op. 163 Quintet. I never knew why this professor singled me out for the gift, since I knew nothing about classical music, but he did and it changed my life.

To obtain *more* records, I started to write record review columns, give lectures about music, and do promotional work for record stores. After that, I produced, wrote and announced several radio shows that featured records, and I managed several record shops. Eventually, I became a wholesale record salesman and distributor. The record business supported me and, in the end, almost ruined me, but it was a big part of my life for 25 years. Even today, some acquaintances still think of me primarily as a "record man," not as a photographer.

CAREER CHOICES

My first career choice had been to be a writer. In fact I became one, but rather than authoring the intended "Great American Novel," I drafted newspaper notices for a neighborhood movie house and press releases for a night club and a radio conglomerate. A few of my poems were published *gratis* in local publications.

Mostly, I wrote about music. An essay about Gustav Mahler was accepted by a national magazine, but the reward (after negotiating trip to New York) proved to be a stack of records and music scores. Many of the articles I wrote required me to interview musicians, classical and otherwise, and allowed me to meet some of the greatest artists of the 20th century, such as Paul Robeson, Louis Armstrong and Marian Anderson.

Other career paths were attempted. Fueled by my success in some college plays I tried acting, but

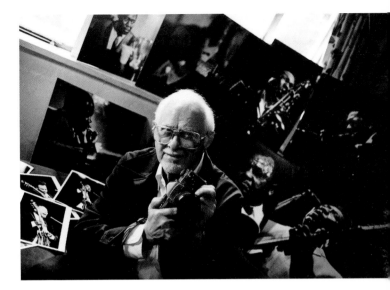

never broke out of the amateur ranks. During World War II I needed to work in a war plant to avoid being drafted, so I became Director of Employee Recreation and Industrial Music at Wright Aeronautical, near Cincinnati. I tried other practical occupations, including a stint making Studebaker automobiles.

PEOPLE'S SONGS

In 1944, after several extended stays, I moved to Chicago from Cincinnati. I was 29 and picked up jobs wherever I could, both in and out of music. I sold auto insurance, but I also lectured on folk music and blues at Parkway Community House, on South Parkway. Those lectures led to my appointment as Midwest Executive Secretary for People's Songs, a national organization that promoted various populist causes through the medium of folk music. This brought me into contact with Pete Seeger, Woody Guthrie, Leadbelly, Josh White, Big Bill Broonzy and others.

Most of what I knew about music up to then had come from records, but the People's Songs experience introduced me to *live* music. When I met Leadbelly and happened to mention that I had all of his RCA releases except "TB Blues," he took out his big 12-string guitar and performed the song for me, right there in his hotel room.

The experiences I had with People's Songs were exciting, but as a job it wasn't much good. At best it covered some meal expenses when concerts or fund-raising efforts were successful. It never paid enough to support a family. Lectures paid my rent on occasion, and a job acting the part of a Sinclair Lewis protagonist in a magazine dramatization of *Kingsblood Royal,* for *Ebony, Life* and *Time,* belatedly contributed a small paycheck. I even ran on the NY Central Railroad as a dining car steward from 1950 to 1955.

IN THE LOOP

In 1955, I was offered the job of sales rep for the wholesale distributor of Folkways Records, selling to record stores in the Loop and throughout the Midwest. I supplemented that income however I could—giving lectures, doing radio shows—and needed all of it to stay afloat. Photography started to pay a few bills after 1959.

For most of my career in the wholesale record business, the action in Chicago was inside the Loop or nearby.

The biggest record stores and record departments were downtown, and I called on all of them. I had the first appointment of the week for record salesmen at Marshall Fields, the big department store. I also called on Lyon and Healy, Kroch's and Brentano's, Carl Fisher Music, Frank's Drum Shop, Hudson-Ross and Rose Records. I remember that Ramsey Lewis managed one of the Hudson-Ross stores.

My access to and rapport with record buyers was primarily due to my knowledge of classical music, which most of them lacked. My other specialty, folk music, was growing in popularity. With Win Stracke, who I knew from People's Songs, I helped Kroch's and Brentano's develop their first record department. Win, an accomplished performer, founded the Old Town School of Folk Music.

Just south of the Loop was Record Row, on South Michigan Ave., where Chess, Checker, VJ and other record labels had their offices, and where I could get promo records to play on my radio shows. Later, I attended Roosevelt University, also in the Loop. In 1959, when I started to take photography classes at the Institute of Design (part of the Illinois Institute of Technology), I moved from Oak Park to Lake Meadows to be closer to the campus.

My "office" during this period was at Astra Photo, at 6 East Lake Street, Chicago 1. ("Chicago 1" was the pre-zip code designation for addresses in Chicago's Loop.) So closely was I associated with that address that sometimes I received mail addressed simply to "Ray Flerlage, Chicago 1."

The Loop was a good, central base for everything I had to do. My daily schedule was tight, but possible because everything was so close and it all tied in together.

MOE ASCH

One of the first record labels I represented as a salesman and promoter was Folkways, operated by Moses Asch, who also launched the Asch, Stinson, Disc, RBF labels and later affiliated with Scholastic Records.

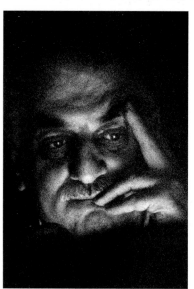

Moe gave me my first assignment as a professional photographer in August, 1959. I was 44 years old and still not sure what I wanted to be "when I grew up." Moe knew I had been studying photography for two or three years, at the Art Institute of Chicago and at the Institute of Design. He knew I had good equipment: two Leica M3 bodies, a Rolliflex, a Hasselblad and multiple lenses. He also knew I was comfortable in the Black community and already knew many performing artists through the newspaper interviews I had conducted and through my association with People's Songs.

When Moe first looked at my work, he said he thought I was best suited for fashion photography because I had shot a lot of pretty girls in pretty dresses. I had never photographed a performing artist before, except a few experimental shots of ballet dancers and coverage of the Bayanihan troupe, a popular folkloric dance company from the Philippines.

So when Moe's telegram arrived, just as I was starting my vacation, it was totally unexpected. He wanted me to photograph the blues singer Memphis Slim at the Pershing Hotel before Slim took off for Europe, and to come up with notes and photos for Slim's new Folkways LP.

The result of that session was a vast set of images that launched my photography career and which continue to

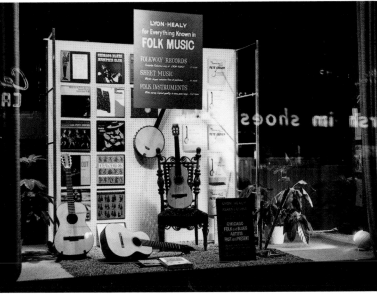

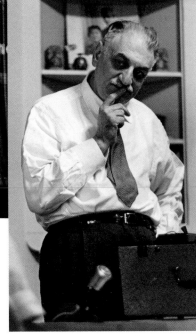

be published all over the world. Several of my friends think I've done nothing better, a left-handed compliment at best.

KINDNESS

In 1944, the South Side of Chicago became my home. I had already effectively moved into the Black community, as most of my social and professional interests and activities were centered there.

As I reflect on nearly 60 years of living and working as a White man in Chicago's Black community, the word that springs most immediately to my mind is kindness. During a time of tremendous racial turmoil, in a city where some of the worst abuses were felt and some of the fiercest battles were fought, I was almost always treated with kindness and acceptance everywhere I went in Chicago's Black neighborhoods.

My first landlady in Chicago was a woman named Arseneaux. She was a great cook from New Orleans who derived immense joy from feeding me, particularly when she had an audience to see how much I could eat. She would put a series of a dozen dishes in front of me and just smile ecstatically as I savored one after the other.

I was not naïve about my decision to live in the Black community. I knew the history, I knew about the prejudices against Blacks and the way they had been treated. There were many good reasons for Blacks to resent Whites.

I became attracted to the Black community, and sympathetic to its plight, when I witnessed racial prejudice as Employee Recreation Director at a war plant during World War II. One of my duties had been to schedule performances by employee bands. I wanted to give preference to the best groups, who generally were Black, but was pressured by my directors to favor the White employees, regardless of talent. Racial prejudice even infected something so trivial. Later, I became semi-official liaison between management and the plant's Black employees at social functions.

Which brings me back to Chicago, 1944. For a White man to even visit the South Side of Chicago in those days was unusual. The first time I got off the el train at a platform on the South Side and started to walk down to the street, the attendant in the ticket booth and the security guard on duty both warned me not to go down. I ignored them because I felt that their prejudice and fear were rooted in ignorance. It wasn't utopia I found at the bottom of that el platform—I experienced racial hostility from time to time—but I experienced much more hospitality, warmth, kindness and acceptance.

LARGENESS OF SOUL

I am still astonished that so many Blacks could so kindly accept a representative of their enemy among them. I am not sure I could have done it. If somebody was kicking me around and hurting my wife and kids, if my kids were afraid to walk up the street because they would get insulted or beat up or worse, I don't think I could love the people who did that. I think it takes a largeness of soul, whatever you want to call it.

Many of the Black musicians I knew had horrific experiences growing up and were treated miserably by Whites, in the South and even after coming North. Yet almost all of them accepted me and some—like Muddy Waters, Memphis Slim, Magic Sam, Little Brother Montgomery and others—showed me exceptional kindness.

I remember Magic Sam walking my wife, Luise, and I across a snow-heaped divider on Roosevelt Road—ignoring the effect on his fine imported shoes—after we had covered his show at the 1815 Club.

It was not just musicians who were kind and accepting. For over a decade I wandered the South Side streets with a fortune in glittering cameras around my neck. I went in and out of Pepper's, Sylvio's, Theresa's, the Trianon Ballroom, the Regal Theater, the Sutherland, McKie's and countless other places many times with no trouble.

FREELANCE PHOTOGRAPHER

After the Memphis Slim shoot in 1959, Moe Asch continued to give me assignments for Folkways and I began to get other photography jobs. Here the words "assignment" and "job" may be misleading. I was a freelance photographer. That means everything was shot on approval. I took the photographs at my own expense, showed them to editors and got paid only for the ones they decided to use. If I sold enough, and was able to collect, I made a profit.

The national magazines *Down Beat, Rhythm & Blues,* and *Jazz* used a lot of my shots, as did a local entertainment publication, *Chicago Scene*. I also sold images to the *Chicago Daily News* on occasion.

Record companies acquired photographs from me the same way publications did. In addition to Folkways, my main customers were Chess, Delmark, Prestige, Testament and Bluesville. Several English labels, like 77 Records, bought occasional prints for album covers, and Horst Lippmann, the German concert promoter, bought prints regularly for his impressive annual promotional brochures.

In addition to selling records and taking photographs, I also wrote, produced and announced three or four different radio shows, with titles like Blues International, Folk City, Meetin' House and Critic's Choice. The radio shows gave me press access to the Folklore Society's annual festivals at the University of Chicago's Mandel Hall, where I could shoot major blues and folk artists en masse, covering 15 to 20 in a single weekend.

As you will see on the pages that follow, I shot in Mandel Hall, the Chicago Opera House, the Trianon Ballroom, the Regal Theater and other large performing venues. I also shot recording sessions in studios, interviews in hotel rooms and rehearsals in basements. I photographed Muddy Waters, Howlin' Wolf and Little

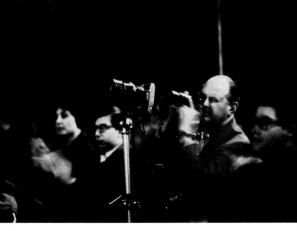

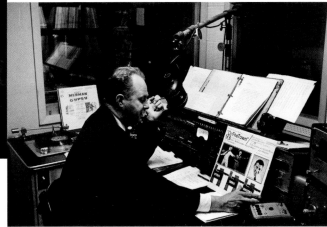

Brother Montgomery in their homes.

Mostly, though, I was in and out of nightclubs all over Chicago, several nights a week: Pepper's, Smitty's, McKie's, the Sutherland, Robert's Show Lounge, the Fickle Pickle, Gate of Horn, the Plugged Nickel, Sylvio's, the 1815 Club, Big John's, Mother Blues, Alice's Revisited, the Ashland Auditorium, Western Hall, the Blind Pig, Hey Rube! and Theresa's.

In 1965, I sat down with a group of friends to talk about putting together a book of my photographs. They were Willie Hopkins, an art director for *Chicago Scene;* Pete Welding, an editor at *Down Beat*; and Mike Bloomfield, a young blues enthusiast. The enterprise fizzled after a few months and everyone moved on to other things. Mike, who the others warned was "too enthusiastic" about the project, went on to international celebrity and legendary tragedy. Willie went to New York as art editor for *Look Magazine,* and Pete took off for the West Coast to work on his Ph.D. in folk music.

Instead of my own book, I got *Urban Blues,* by Charles Keil, which appeared in 1966 to unanimously favorable reviews. My photographs were featured on the front and back covers, and most of the inside shots were mine as well.

By the late '60s, with Pete no longer at *Down Beat,* and with the folding of *Chicago Scene* and the *Chicago Daily News,* I had few remaining outlets for my photographs in the United States. I continued to cover the annual University of Chicago Folklore Society concerts at Mandel Hall, and I still got inquiries and print orders from Canada, England, France and Germany, as well as from American record companies like Chess, MCA and Delmark, but overall my photography business was pretty quiet.

KINNARA INC.

In 1971, the Folkways distributor I had been representing for 16 years suddenly went out of business. I lost my job, and several record label owners, many of whom were my close friends, lost their distribution in Chicago and the Midwest. People like Pete Welding, who owned Testament, and Chris Strachwitz, who owned Arhoolie, urged me to start my own distributorship and pick up their lines, which I did. Several then dropped me as soon as bigger companies offered to pick them up.

Kinnara Inc., my distributorship, was undercapitalized from the beginning. It was a struggle to keep the

business afloat against intense competition. I worked at it constantly and had to give up photography, and my radio shows. Those were thirteen hard and frustrating years.

During that period I continued to receive the occasional print order for documentaries, record re-releases, jazz and blues exhibits, instruction books and magazines but my photo career was, for all practical purposes, a dead issue.

RETIREMENT CAREER

When Kinnara closed in 1984, I lost all my money. It had already cost me my other enterprises and I was experiencing a tremendous sense of failure which extended to my family relationships. The revival of my own interest in my photography, and life in general, began with two unusual documents.

The first was a long story written by a young woman about her mythical uncle who, from wonderfully evocative incidents evolved in the glow of old memories, was recreated in words that revealed deep love. Although it came from a relative who I thought had been estranged by a deep family misunderstanding, I realized her loving description was of myself.

The second document was a letter I received from Val Wilmer, the internationally renowned photojournalist with whom I had shared the pages of *Down Beat* and *Rhythm & Blues* magazine back in the 60's. She wrote:

"I have seen your pictures over the years in *Down Beat* and other places and have remained a great admirer of your work. No one else has taken the kind of moody action shots that you took in Chicago, so full of atmosphere and so full of the blues. Truly I love them."

As they say in the Bible, the scales fell from my eyes! So it had been worthwhile after all! The years of obscurity, the loss of identity, the struggle simply to sustain the enterprise had not been for nothing! Pete Welding, Mike Bloomfield and Willie Hopkins were gone. The *Daily News* and *Chicago Scene* were gone, but the images I made during that period were still being seen and admired by knowledgeable eyes! What more could a starving artist ask for?

I started to get calls again for my photographs. Supplying that demand has been my retirement career, and it has kept both me and my wife, Luise, jumping. I still am constantly having new prints made, always at Gamma Photo Labs, successor company to Astra Photo, where I used to have my "office."

Today, my home is still on the South Side of Chicago, near Jackson Park and the lake, where I live with Luise.

COME INSIDE

Although my life and assorted careers had their ups and downs, I was lucky in the long run. I was in the right place at the right time, with film in my cameras. I am most grateful for the fact that I was able to become an "insider," with many of my photographic subjects becoming my friends. It made the work that much more enjoyable!

Through recordings, we can still hear how the Chicago blues scene of the 1960s sounded, and now with this book you can see what it looked like too. I hope it will be as memorable an adventure for you as it was for me.

Raeburn Flerlage
Chicago, April 2000

ACKNOWLEDGMENTS

I keep turning a phrase over in my mind: "All action is interaction." I am not sure if it makes sense, but I know I would have fallen by the wayside long ago if it had not been for colleagues, friends and family who sustained me with encouragement, advice, contacts and opportunities.

The person most responsible for launching my photography career was recording pioneer Moses Asch, founder of Folkways Records. Moe was one of the great nurturers of talent in our time, and I was honored by his friendship, and by his belief that I had talent worth nurturing. He was my main mentor through all the early years.

As I was learning the craft, several well-established Chicago photographers including Steve Deutch, Yuichi (Gene) Idaka and Jo Banks gave me helpful advice. I also learned a lot working with Wayne Miller as he photographed me as protagonist in the pictorial condensation of Sinclair Lewis' *Kingsblood Royal* for *Ebony* magazine, reprinted almost simultaneously in *Time* and *Life*.

I received both personal encouragement and advice from Harry Callahan, with whom I studied at the Institute of Design, after leaving the Art Institute of Chicago in the late '50s. While his style was totally different from my own, Callahan's unrestricted approach and vision were inspiring.

During my most active years as a photographer, partners Ted Williams and the late Jim Taylor, both younger but more experienced colleagues, generously shared their contacts, opportunities and know-how with me. Ben Lavitt and Harold Smolin, owners of Astra Photo Labs, gave me the use of their prestigious address at 6 East Lake Street, Chicago 1, as my base of operations.

Ted Williams introduced me to Pete Welding, editor of *Down Beat* magazine, who lined me up with many jobs and sometimes went along with me on them. Through Pete I met Mike Bloomfield, then an up-and-coming blues hopeful wheedling technical tips from the established masters we interviewed. I would often run into Mike (sometimes with Charlie Musselwhite and Paul Butterfield) at Pepper's Lounge, and sometimes at the Trianon

Ballroom as well. I also saw him at the Fickle Pickle, which he helped run, along with Bob Koester.

Pete Welding and Jim Taylor together got me in touch with Willie Hopkins, an editor, like Jim, at *Chicago Scene* magazine. Willie won a couple of design awards in 1961, one of which featured some of my minimalist Pete Seeger shots on the cover.

While I was covering the annual University of Chicago Folklore Society concerts at Mandel Hall I benefitted from the cooperation of a photography colleague, Stan Shapin, and from my WXFM broadcasting partner, Al Urbanski, who sometimes manned a camera to back me up. Both took shots of me that you'll see in the Introduction.

Throughout all these years, income from the photographs remained small and expenses high. I worked in several other fields—record sales and promotion, radio production and announcing, and column writing, for the necessary income. From 1971 through 1984 I also operated my own wholesale record distributorship, again representing Folkways. After this final enterprise collapsed and a sense of personal failure overwhelmed me, I received two unexpected communications that lifted my spirits and put me back on the right track. Both of those authors deserve my deepest gratitude—my niece, Alice Niles, a gifted Illustrator, and the noted London-based photojournalist, Val Wilmer.

In 1995, Charles K. Cowdery, who remembered my photographs from an earlier association, featured them extensively in his book *Blues Legends*. And James Fraher, a prominent young blues photographer, and his wife Connie Scanlon, an outstanding designer, contacted me and we started a friendship and a relationship that has led to exhibits, poster sales and mutual referrals.

I also owe thanks to Pete and Toshi Seeger, Studs and Ida Terkel, Peter Amft, Dick Eastline, Lee Tanner, Tish King, Simbiat Hall, Bob and Sue Koester; Carrie Hester, Al DeBat, and Peter Panayiotou of ASMP; Vartan, Drew and Georgette Cartwright, Elaine Cohodas, Aaron Siskind, Ella Jenkins, Steve Wagner, Bruce lglauer, Sam Charters, Chris Strachwitz, Michael Ochs, Frank Driggs, Geary Chansley, Bob Bass, Erwin Helfer, Scott Barretta, Dan Quigley and Len Bukowski (successive owners of B-Side Records, who exhibited my photos in the store), Jack Leblebijian (producer of master prints, who remains one of the greatest of all lab technicians), Clifford B. Radix, Ronald Clyne, Gino and Bernadette Battaglia of Blue Chicago, Jim Jaworowicz, John Wawrzonek of Light Song Fine Art, Cary Wolfson, Leland Rucker, John Sinclair, Andy Robbles, Mary Monseur and Kip Lornell of Smithsonian Folkways, and Eric Kingsbury and Richard Siegle of Fender Musical Instruments.

The famous New York photographer Dave Gahr and I used to exchange messages by way of Moe Asch during Moe's visits back and forth between New York and Chicago. I remain indebted to Dave for the expert tips he sent, while overlooking some of my irritating pricing foibles in the old days, and for encouragement and valuable professional tips extending into the present.

In a book of this kind, preparation of quality prints is of primary importance. I acknowledge that ideally the photographer should print his own work. That could not be achieved in this instance because of the multiple bill-paying operations described earlier, plus continued studies at Roosevelt University and frequent business trips. I closed my darkroom in the mid-60's and for many years depended on the great master printer of Gamma Photo Labs, Jack Leblebijian, to work his magic. Jack had opened Gamma with its owner, my old wartime friend Mickey Pallas, back in the early '60s. But both he and Mickey were now retired, and so Gamma's order coordinator, Butch

Connelly, who was overseeing and expediting all our work on this book, referred me to Varouj for optimal quality processing. When I found that Varouj Kokuzian had been trained by Jack "Leb" (and was in fact his son-in-law!), I knew I was in good hands. The results have borne out my faith. Jack can be proud of his master student!

Thank you Butch!
and thank you, Varouj!

My relationships with the subjects of this book were powerfully influenced by many other famous individuals who are not pictured here. Through newspaper interviews and other activities I was fortunate to meet and talk with several of the most famous artists of our time: Paul Robeson, Louis Armstrong, Sidney Bechet, Duke Ellington, Leadbelly, Woody Guthrie, Marian Anderson, Burl Ives, Big Bill Broonzy, Ravi Shankar, Josh White and many others. The Chinese have a saying that "Great men do not feel great, small men do not feel small."

You can recognize the great ones by the fact that they do not posture. They have no need. They are willing to relate to you as one human being to another.

The second-raters posture. "By their posturings you shall know them."

This knowledge helps you to interact effectively with the famous.

I also owe a debt to several great bluesmen who gave me special help and friendship: Memphis Slim, Muddy Waters, Little Brother Montgomery and Sunnyland Slim, who perfectly illustrate the phrase that keeps running through my mind, "the camaraderie of the blues."

I must acknowledge that the production of a book like this would have been impossible for someone with waning talents and fading memories, suffering the frustration of sorting through papers, letters, negatives, articles and notes covering more than half a century without the understanding, support and many extraordinary talents of my wife, Luise. She did what people now refer to as "the heavy lifting." So this book is for her in gratitude.

In closing, I particularly want to say "thanks" to Lisa Day for her wonderful vision and insight into what is possible, and even more for her incredible faith, support, boundless energy and warm friendship. Five years ago she formed a concept of what this book should be and she has made it happen. You can blame anything that's wrong with this book on the perpetrator cited below. The good stuff comes from Lisa and Luise!

So how about looking it over now?

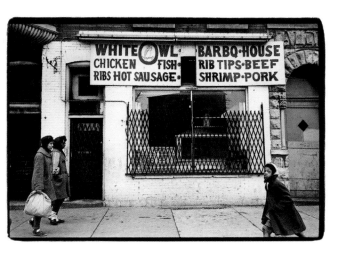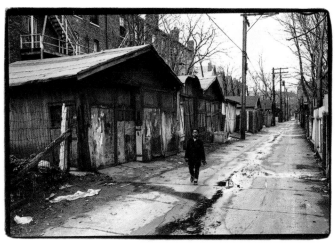

Genius, even outstanding talent, comes less from intellectual gifts and a social refinement superior to those of others than from the faculty of transforming or transposing these things...

Genius consists in the power to reflect and not in the intrinsic value of the thing reflected.

—Marcel Proust

Editing this book has been an extraordinary experience for me. Not only have I learned a heck of a lot from Ray about blues music, but I've also benefitted from his vast knowledge of classical music and literature. At any moment our conversation can pinball from Chekhov to Muddy Waters to Proust, from Memphis Slim to Mozart and somehow, wildly but logically, make its way around to the camaraderie which serves as the very foundation of the blues musician in general, and this blues photographer in particular. Ray's excellent technical skills as a photographer are obvious. His shots are simply wonderful. But, for me, his real gift resides in his ability to reflect the goodness, the talent, the "heart," the brotherhood of the blues musicians. He is the mirror Proust speaks about so eloquently. I can't thank Ray and Luise enough for all they have given me over these last five years. They opened up their hearts and their home and trusted me with Ray's life's work.

In the end, and by way of Fat Sam, I have enjoyed a delightful journey and gained a beautiful friendship for which I will be forever grateful.

I wish to thank Dave Johnson, my friend and gifted designer, for his generous support, encouragement and insightful advice. His input was invaluable, inspiring and grounding.

And finally, it's with much love and appreciation I say thank you to Robert Sandstrom for his unflagging interest in my work, and his extraordinary patience and tolerance for having to chase me all over the country. Our relationship has inspired me to explore new realms of creativity and sustained me when I didn't think I could.

Lisa Day
New York, April 2000

Chicago Blues

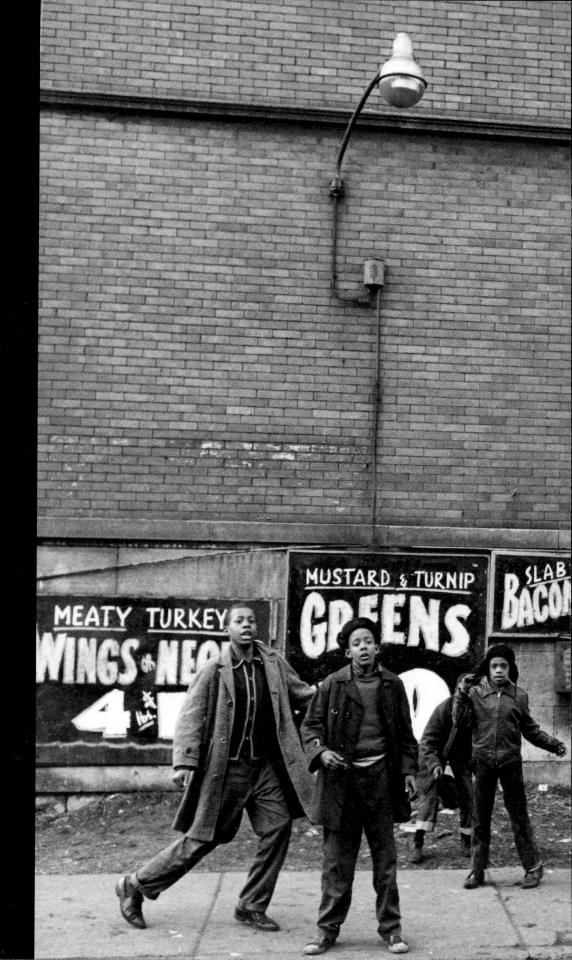

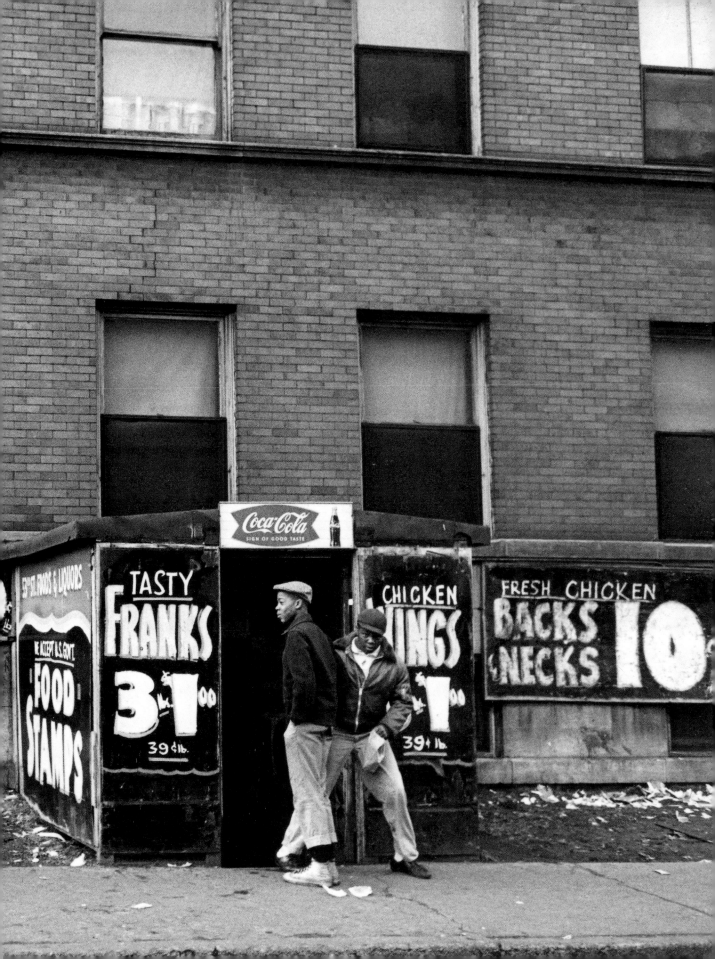

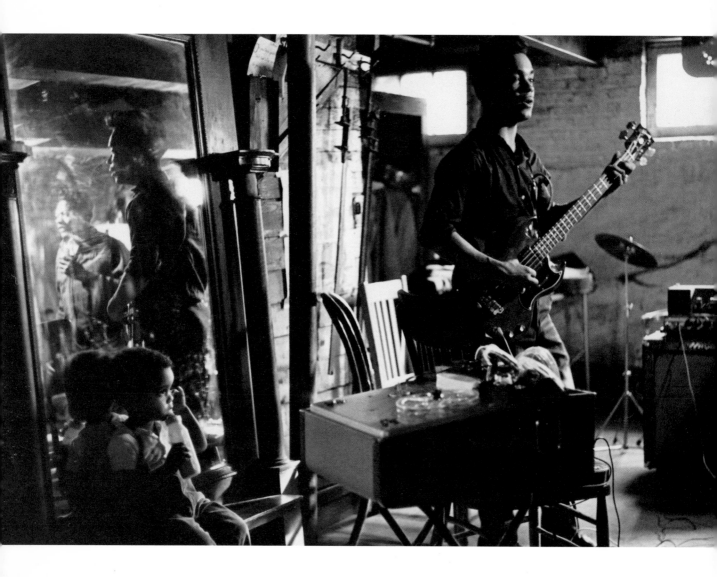

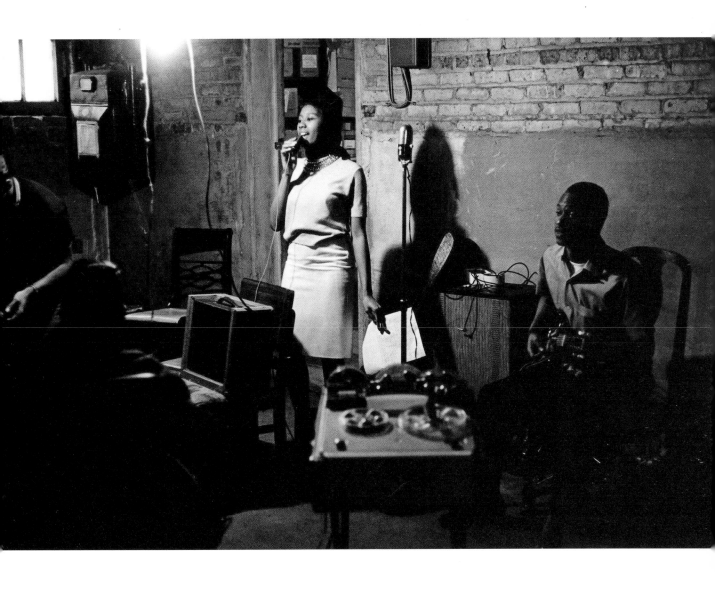

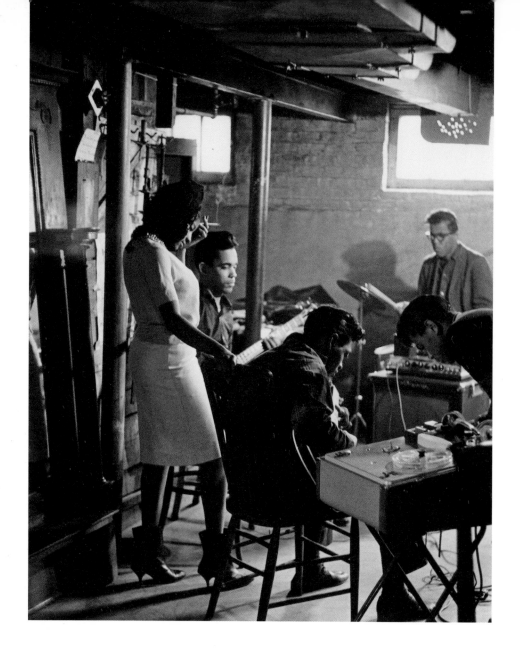

A group of unknown musicians rehearses in a Southside basement. Their focus is a curvaceous young lady, just going on 19. I had seen her before at concerts, where she attracts a lot of attention wherever she moves, including from band members on the stage. I recall several members of Lloyd Price's band seemed quite interested during a show at the Trianon Ballroom.

She calls herself Fifi. She wants to be a singer and the rehearsal is, in part, a try-out. The young men in the group share her dream of hitting the "big time." They want to run through a few numbers to decide if she can really *sing*. Curves are one thing...

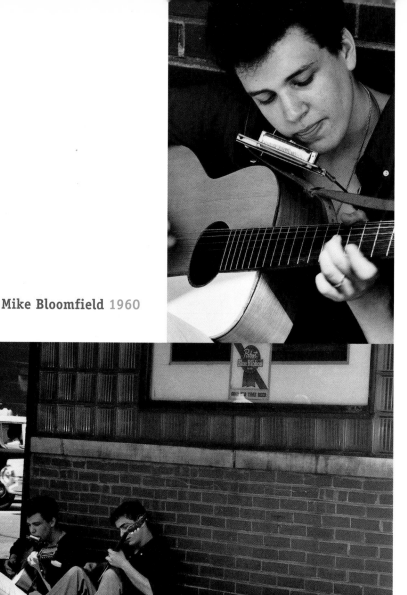

Mike Bloomfield 1960

Pete Welding introduced me to Mike Bloomfield, and Mike and I often worked as a team, him interviewing

and writing, me taking pictures. Usually I was his wheels too.

We ran into each other frequently. Once, I saw him at one of the art fairs on the Near North Side. Mike

was sitting on the pavement, playing his guitar with a harp around his neck and a tin cup in front of him.

Funny to see a rich kid like that busking on the street, but he was imitating his idols, whom he had seen

performing for tips on Maxwell Street.

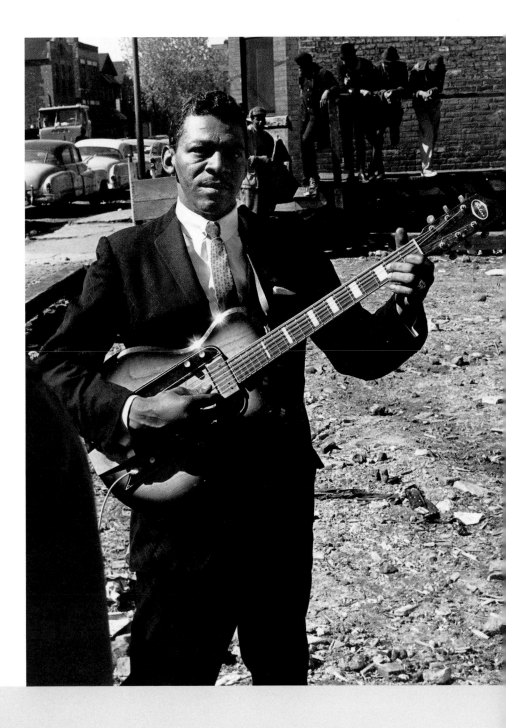

In 1963, the guitarist on Maxwell Street who walked up and asked to have his picture taken was unknown to me. When I sent the shot to *Rhythm & Blues* magazine, it was captioned, "unidentified singer on Maxwell Street."

Later, I learned he was Little Walter (Walter Jacobs), even then a top blues recording artist, who is considered the best blues harp player ever. When he busked on Maxwell Street, he played guitar to avoid trouble with the musicians union.

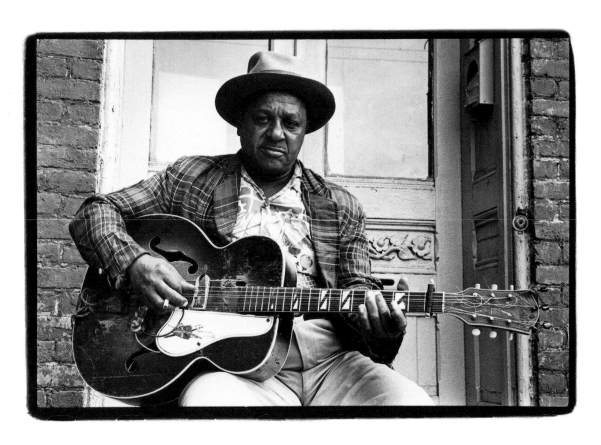

Big Joe Williams 1962

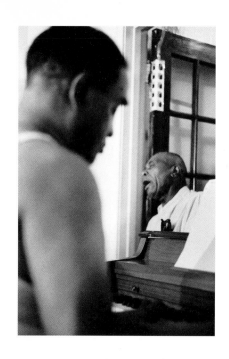

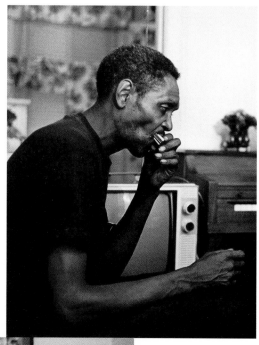

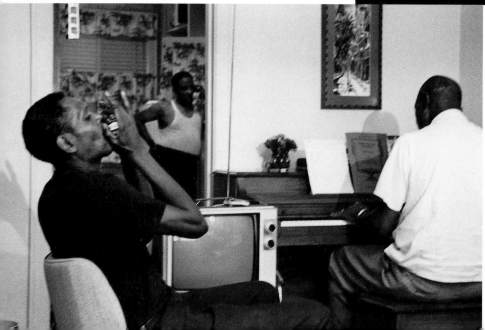

Sunnyland Slim, Big Walter Horton, Little Brother Montgomery 1947

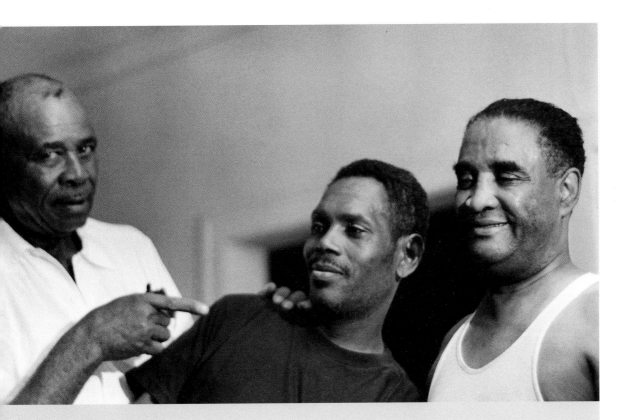

His wife Jan called him LB. Other people called him "Brother." The world knew him as Little Brother Montgomery: pianist, vocalist, composer of "Vicksburg Blues." Little Brother Montgomery was my friend for many years. Although recognized by his colleagues as a formidable blues master, he never achieved the popularity or commercial success of lesser artists who had more flair, drama and pizzazz. He never seemed totally comfortable in the role of bluesman. He would have preferred to play a wider range of music.

The party was at Little Brother's apartment. It was a very hot day. Sunnyland Slim was there as was Oliver Alcorn, the reed player who had recorded with Little Brother in 1947. Big Walter Horton was there and determined to be the life of the party. He clowned with his harps, turning them around inside his mouth, blowing into them through his nostrils, getting wild sounds with the harp sticking sideways out of his face. Little Brother always felt he was under-appreciated and had been cheated by Folkways and other record companies, but he and Sunnyland Slim had a mutual admiration society going. Whenever I did an interview with one of them, he would always extol the virtues of the other over his own.

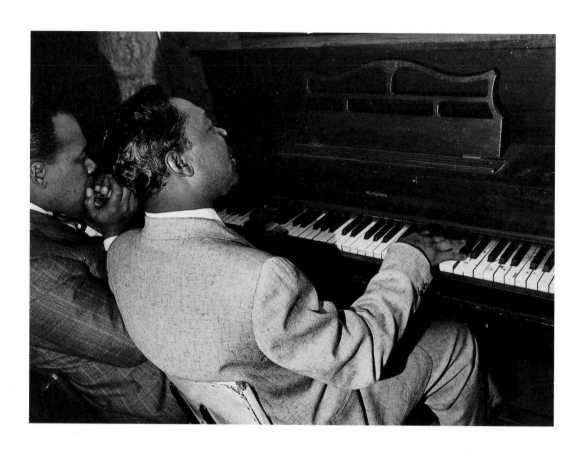

Otis Spann on piano with James Cotton 1965

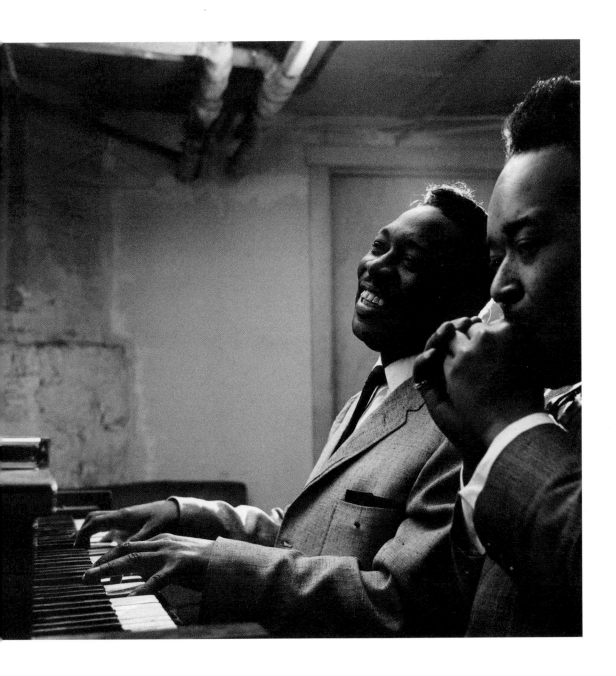

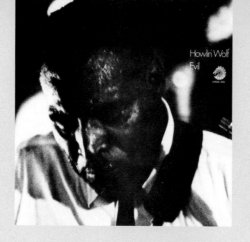

Howlin' Wolf
Evil

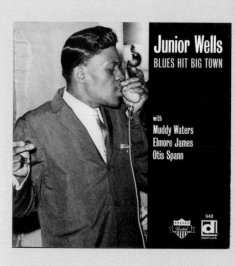

Junior Wells
BLUES HIT BIG TOWN

with
Muddy Waters
Elmore James
Otis Spann

640
delmark

Shoe Shine Johnny (Shines)
with Little Walter
Robert Nighthawk
Honey Boy Edwards
Floyd Jones
with Little Walter
Big Boy Spires
Blue Smitty

Drop Down Mama

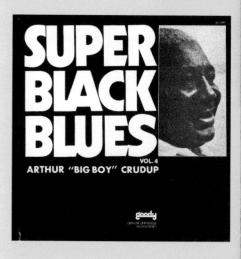

SUPER
BLACK
BLUES
VOL. 4
ARTHUR "BIG BOY" CRUDUP

goody

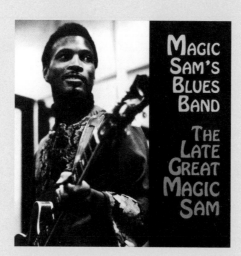

MAGIC
SAM'S
BLUES
BAND

THE
LATE
GREAT
MAGIC
SAM

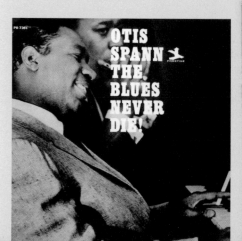

PR 7391

OTIS
SPANN
THE
BLUES
NEVER
DIE!

PRESTIGE

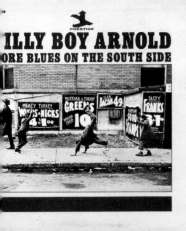

ILLY BOY ARNOLD
ORE BLUES ON THE SOUTH SIDE

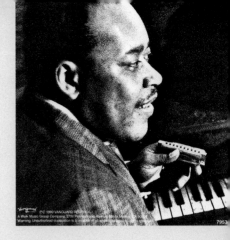

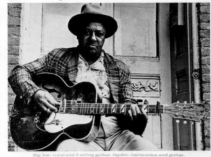

Big Joe Williams
piney woods blues

Big Joe: vocal and 9 string guitar. Jaydee: harmonica and guitar.

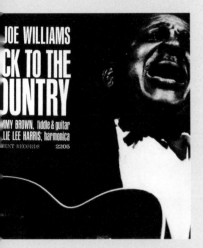

JOE WILLIAMS
CK TO THE
OUNTRY

MMY BROWN, fiddle & guitar
LIE LEE HARRIS, harmonica

ENT RECORDS 2205

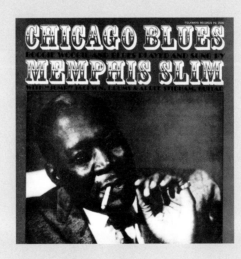

CHICAGO BLUES
BOOGIE WOOGIE AND BLUES PLAYED AND SUNG BY
MEMPHIS SLIM

WITH "JUMP" JACKSON, DRUMS & ALBEE SPEARMAN, GUITAR

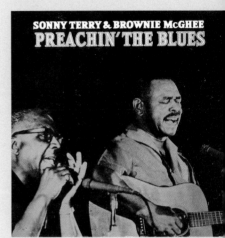

SONNY TERRY & BROWNIE McGHEE
PREACHIN' THE BLUES

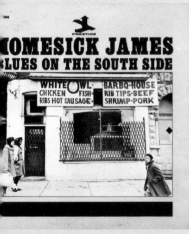

HOMESICK JAMES
BLUES ON THE SOUTH SIDE

WHITE OWL
CHICKEN · FISH
RIBS · HOT SAUSAGE

BARBQ-HOUSE
RIB TIPS · BEEF
SHRIMP · PORK

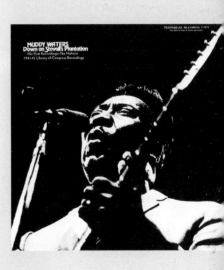

MUDDY WATERS
Down on Stovall's Plantation
His First Recordings—The Historic
1941-42 Library of Congress Recordings

MY HOME IS IN THE DELTA
Blues and Spirituals by Fred and Annie Mae McDowell

TESTAMENT T-2208

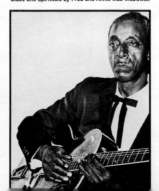

Willie Dixon's astonishing career as a performer, songwriter, arranger, promoter, producer, artist's representative and in many other roles established him as a singular figure in Chicago blues: more important even than Muddy Waters in many ways. He called his autobiography "I Am the Blues," and at least so far as Chicago was concerned, it wasn't too big a claim.

Willie Dixon was the main A&R man for Chess Records. He also played bass on many Chess sessions.

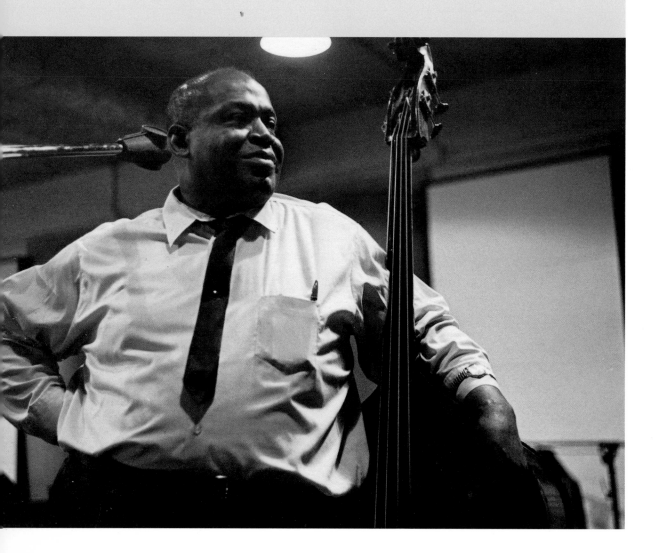

Willie Dixon 1968

Jimmy Dawkins, Lurrie Bell, Carey Bell 1968

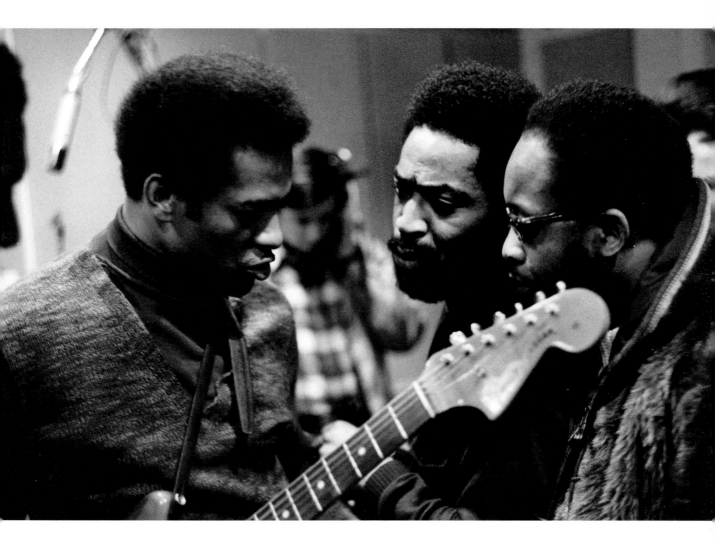

Lafayette Leake 1970

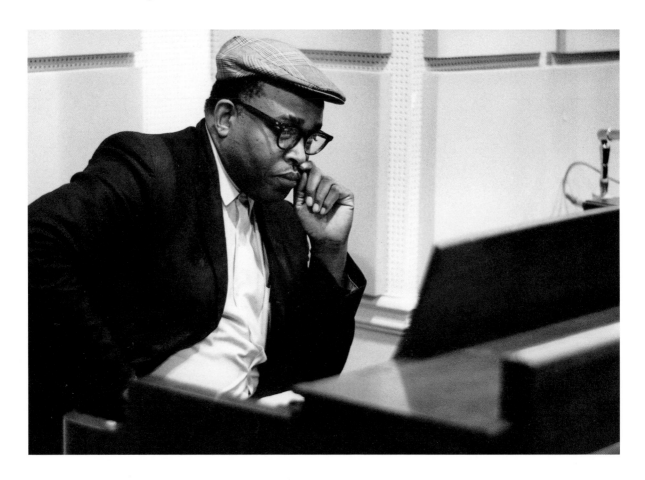

Eddie Shaw 1970

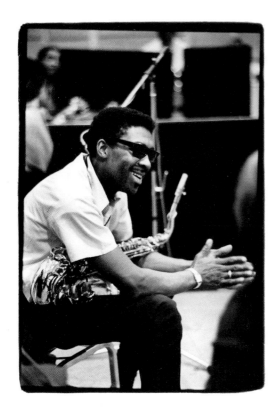

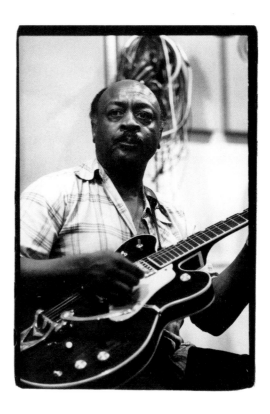

Robert Lockwood, Jr. 1970

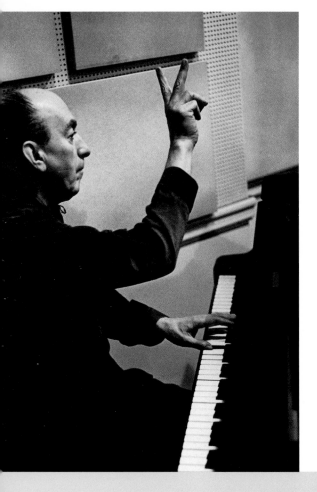 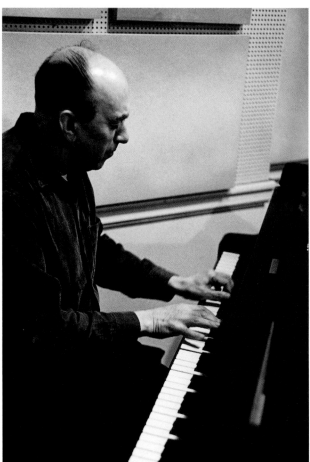

My admiration for Art Hodes began with his Blue Note records—some of them with the great genius of the soprano (and clarinet) Sidney Bechet. Art's slow blues, solo or ensemble, were wonderful to hear—sad, deep, contemplative, evocative of long-forgotten memories of things that might have been.

When our young pianist friend Irwin Helfer asked me to MC a Hodes appearance, I felt as honored as a Nobel recipient. And when Art asked to use some of my prints for his promotional flyer, it was icing on the cake. Art's sound, second only to Spann's, lingers in the memory.

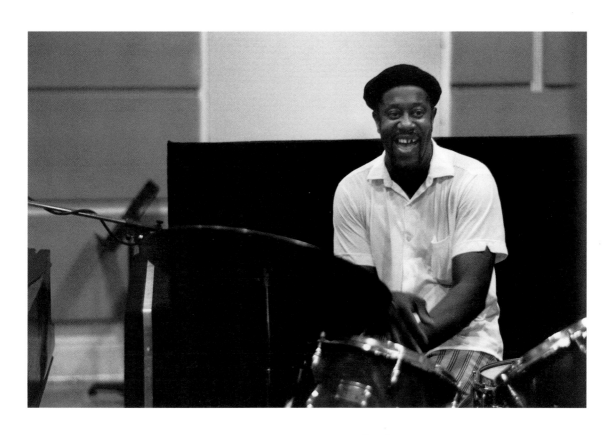

Fred Below 1970

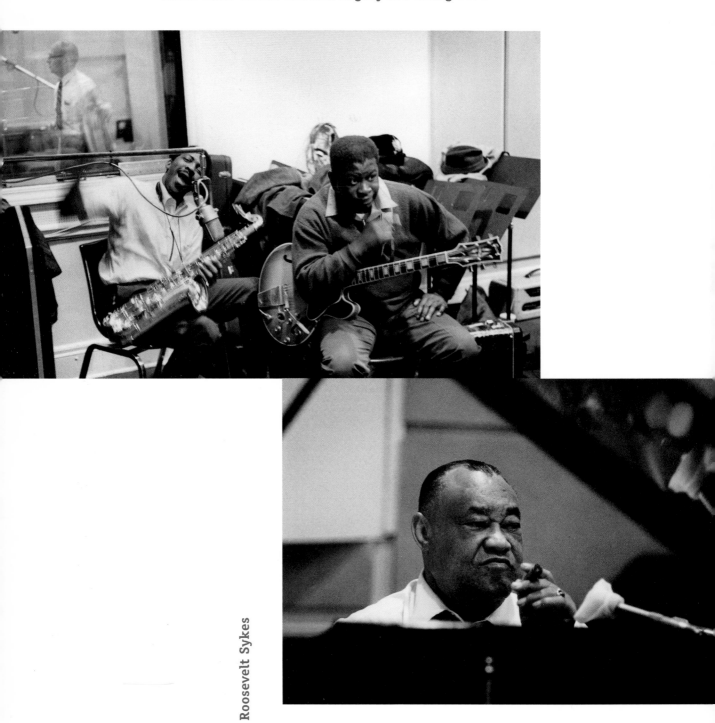

Roosevelt Sykes

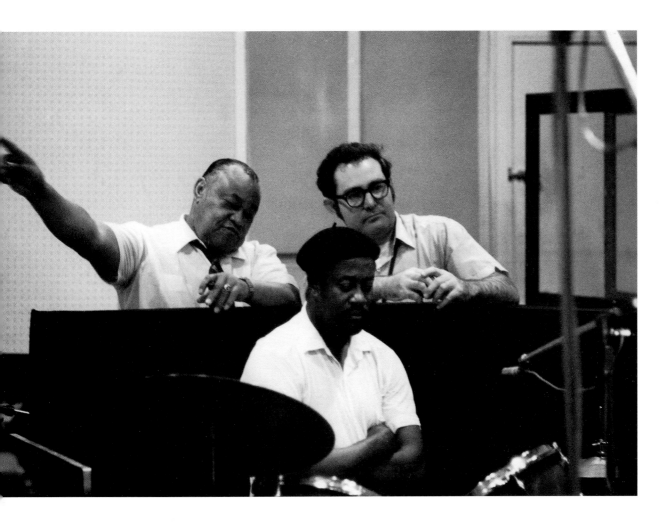

Roosevelt Sykes, Fred Below, Bob Koester

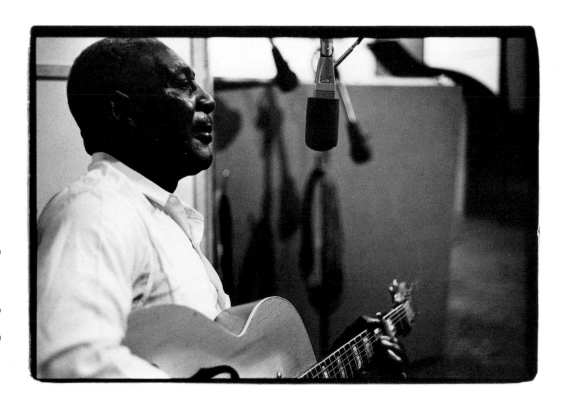

Arthur "Big Boy" Crudup 1968

Arthur "Big Boy" Crudup had been a "known name" in the blues for more than a generation when we shot

his Delmark recording session in 1968.

The camera didn't faze him; he was just taking care of business when we got this nice profile.

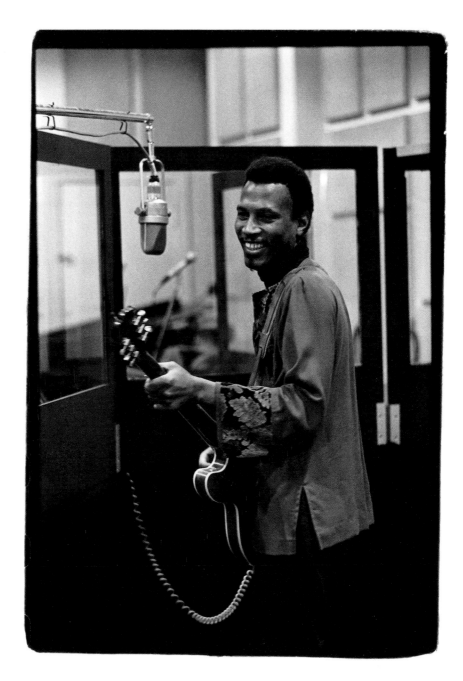

Magic Sam 1968

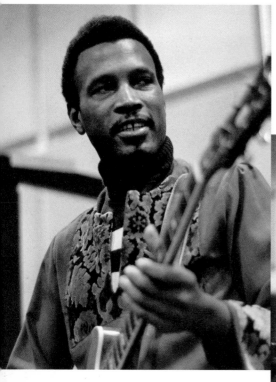

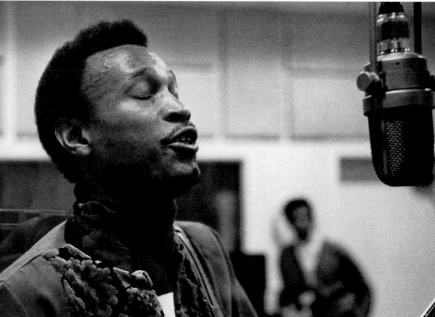

It's difficult to write about Magic Sam (Sam Maghett), even 30 years after his death. The reality seems unreal, impossible to accept without serious mental and emotional gear-shifting.

Sam's life and death raise questions that can't be answered, about artist exploitation, self-discipline and the meaning of "success." Are there really "star-crossed" individuals, who are "born under a bad sign"? Sam Maghett experienced terrible problems and setbacks in his short life, as well as extraordinary accomplishments. True to form, his troubled life ended abruptly, just as he reached the pinnacle of success.

Sam struggled for years against ill health, the Army, the musicians union, exploitative management and parsimonious record companies. He died broke and in debt. On the plus side, his breakthrough album, "West Side Soul," received the highest rating ever given a blues album by *Down Beat,* and a still more successful album had been released just before he died. Both *Down Beat* and *Rolling Stone* recognized in Sam the emergence of a major new artist, a considerable force in the blues world. Sadly, it wasn't to be.

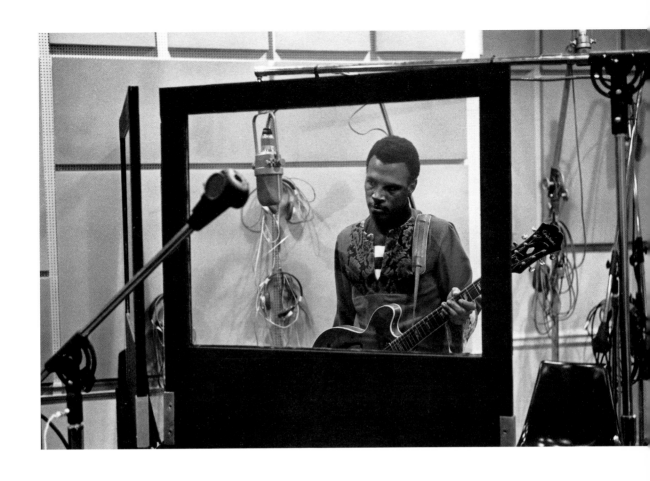

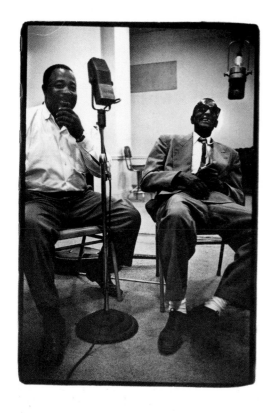

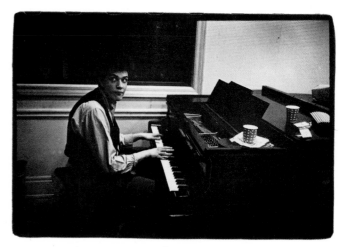

Mike Bloomfield

Hammie Nixon and Sleepy John Estes 1963

Mike Bloomfield was incredibly active in the blues, early in the '60s. I saw him at every major blues perfor-

mance. He worked with Pete Welding and me on interviews we did with John Lee Hooker, Howlin' Wolf and

Muddy Waters, and he helped arrange and manage blues performances at the Fickle Pickle night club, working

with Bob Koester. At several University of Chicago concerts, he backed up Big Joe Williams on acoustic bass.

Mike's ingratiating manner and amazing facility on several instruments—guitar, piano, blues harp and

acoustic bass, among others—helped him bond with the bluesmen he met. In many ways, I think they

sensed a kindred spirit despite a vast difference in backgrounds.

Sometimes Mike would take notes, always frantically it seemed. At other times he would try out the

instruments of the legends he so obviously adored. These experiences were his entry into the "big time."

Unfortunately, they couldn't fortify him for the dangers that came with the package.

The picture of Mike Bloomfield at the piano reminds me of the time he was a guest on my WSBC radio

show. Mike was playing the studio piano exuberantly. Suddenly Louie Lee, the station manager, stormed

in and complained about the loud volume. Mike stopped and we left. Soon promoters and producers were

paying thousands of dollars for similar performances.

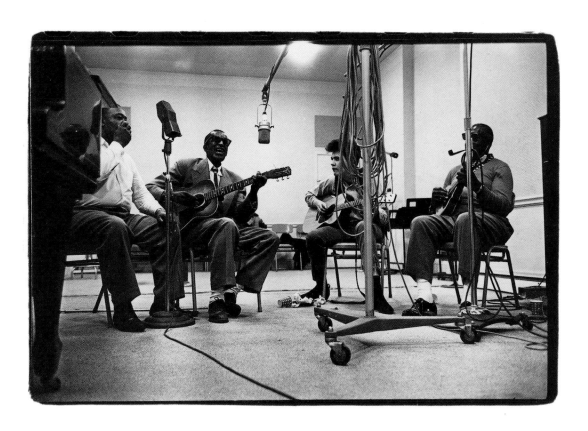

Hammie Nixon, Sleepy John Estes, Mike Bloomfield, Yank Rachell 1963

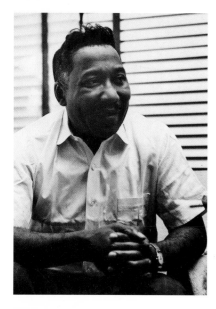

Muddy Waters 1964

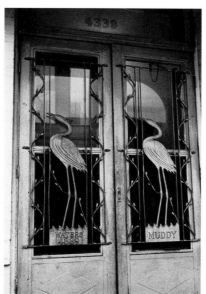

In 1964, Mike Bloomfield and I interviewed Muddy Waters for *Rhythm & Blues* magazine. He was the most influential blues singer of modern times and one of the nicest guys you would ever want to meet. As Mike wrote: "Muddy is warm and generous in his judgments of other blues men. Of one Muddy said, 'He had a heart full of talent.'" Mike, of course, would always try to get some performance tips. "I have a funny feeling," said Muddy, as we prepared to pack our gear. "I have a feeling a White is going to get it and really put over the blues," he continued, "but I don't know whether they can deliver the message. I know they feel it, but I don't know if they can deliver it."

Muddy was the same in his home as he was backstage. Muddy was always just Muddy. He always made me feel at home.

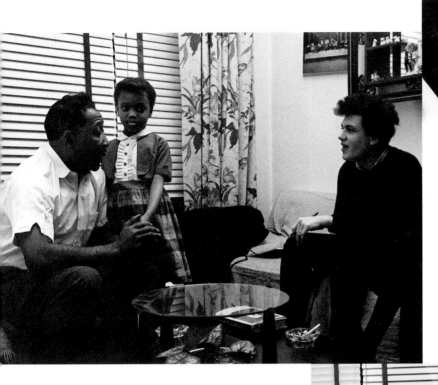
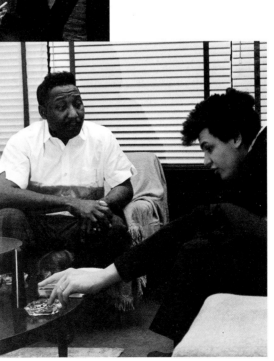

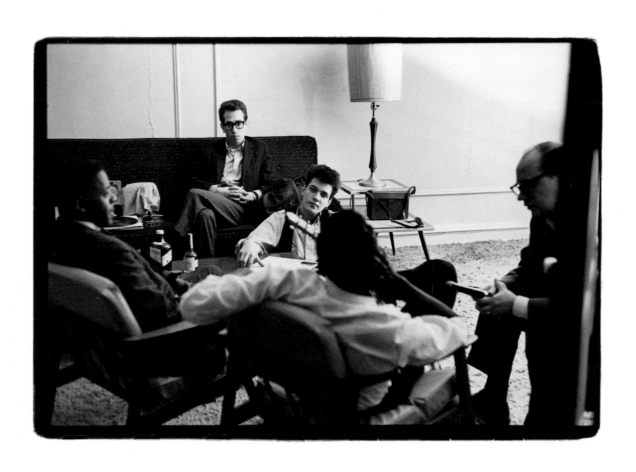

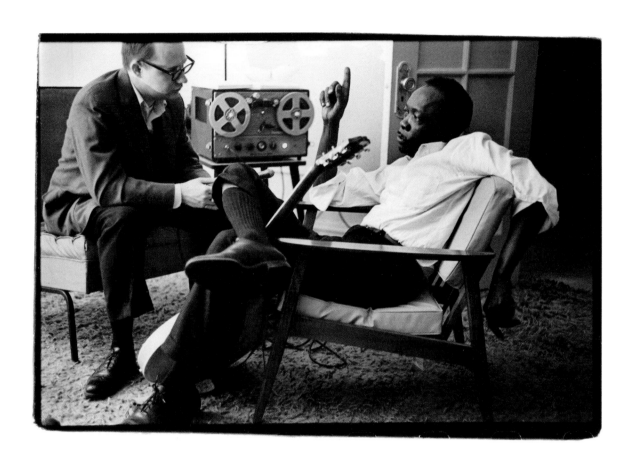

Pete Welding and John Lee Hooker 1964

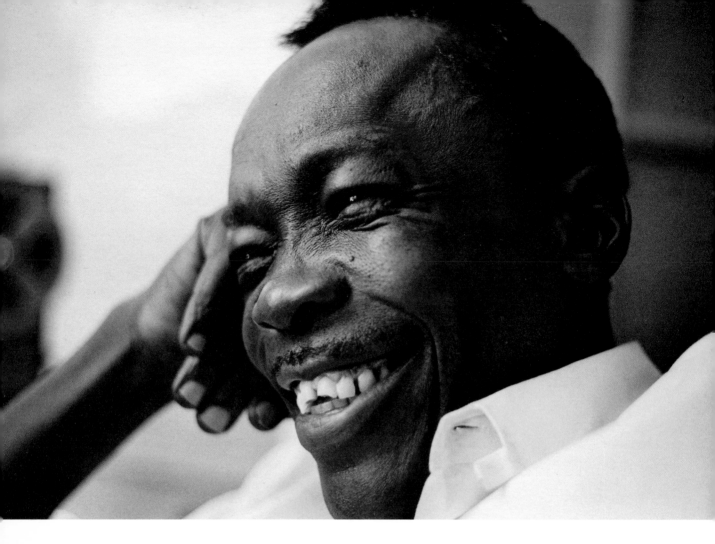

John Lee Hooker 1964

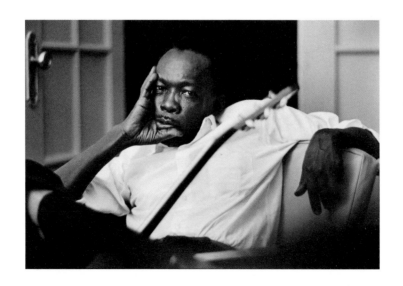

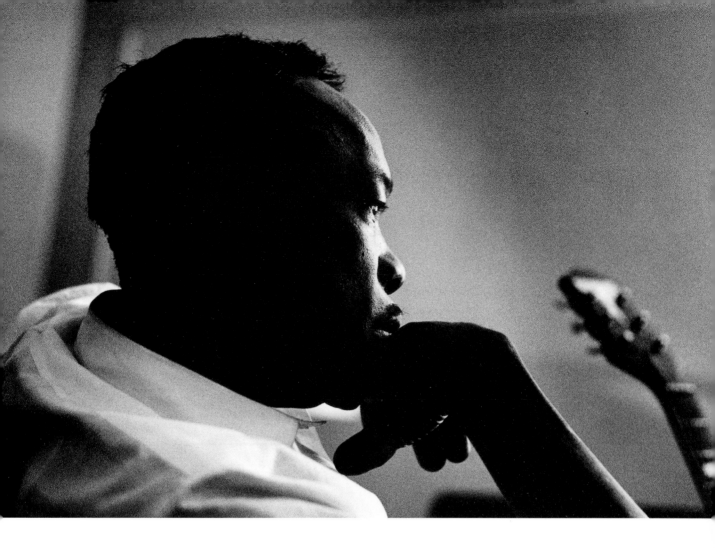

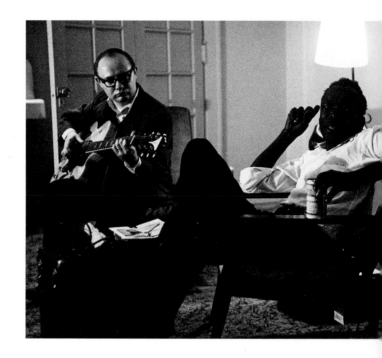

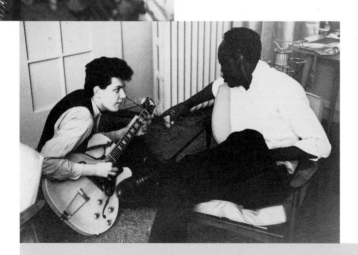

I knew Pete was well versed in the intricacies of the guitar and structures of the blues, but was surprised when he picked up Hooker's guitar, and started to play with the blues master sitting right in front of him. It took an audacity that Pete normally didn't show. I expected it from Mike but not from Pete.

Mike's obvious adulation of the great blues men, and his astonishing mastery of several instruments, persuaded them all to give him private tips on technique and different performance styles. On this trip, John Lee Hooker points out a specific fretting nicety.

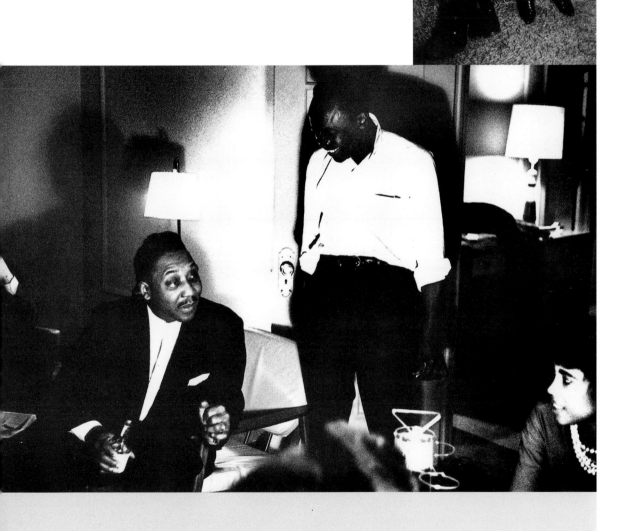

After the interview was over and we had dismantled the lights, Hooker suddenly announced he was going to

call Muddy and ask him to come over. He did. We stuck around. When Muddy arrived, we set up the lights

again but couldn't get some of them to work. Some lights can't be started again while warm. Because of the

historical significance of the meeting I continued to shoot anyway, hoping the underexposed shots could

be saved in the darkroom. They couldn't. Here is the result of our best efforts.

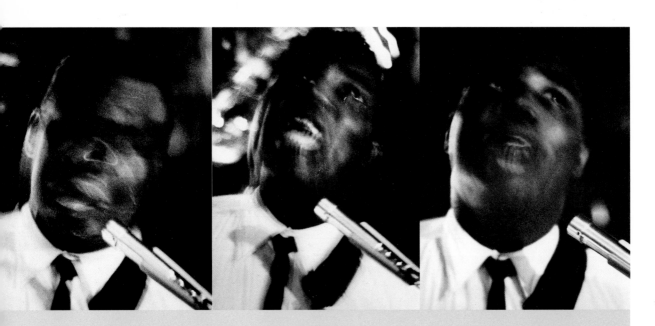

Howlin' Wolf was playing in a little Southside joint called Mr. Lee's Lounge when I first had the opportunity

to photograph him. It was September 12, 1962. There was no table available and not enough light to jog my

light meter. I had to shoot across the bar using my elbows as a tripod base. It worked OK as long as he

stayed pretty motionless, but when Wolf started to gyrate and "howl" everything was up for grabs.

The developed negs show Wolf's teeth as if they had scratched across the film. It looked like a man

becoming an animal right before your eyes. When Leonard Chess saw the shots he was outraged. After using

some of the more colorful language for which he was famous he said, "They look like a #$?#% x-ray!" He

picked a safer shot that he thought looked most "Evil" and put it on the album cover.

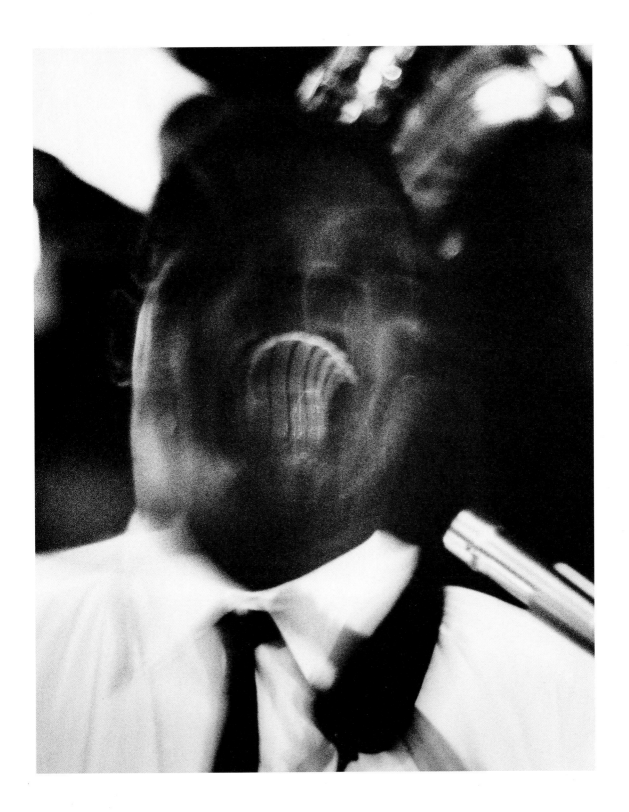

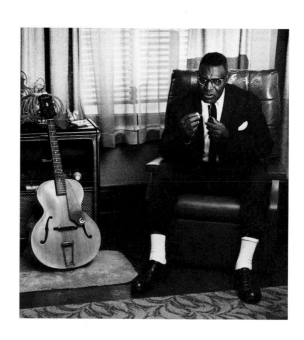

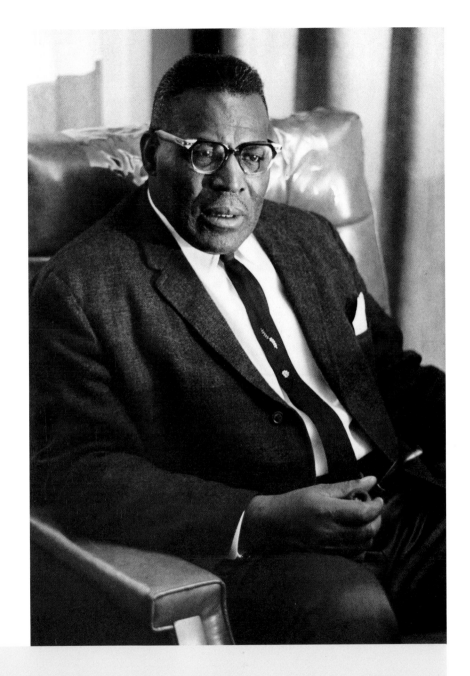

About 16 months after the session at Mr. Lee's, Mike Bloomfield and I interviewed Wolf at his home for

Rhythm & Blues magazine. It was then that I found out how much he disliked those earlier images.

"I'm no animal! I'm a *man!*" he protested.

On stage, Howlin' Wolf performed in a menacing, rough, gruff, sometimes absurd way, with all sorts of

facial contortions, clowning and grandstanding. At the same time, he didn't want to be viewed like that in

"real life." He wanted to be seen as he is here, sitting in his easy chair with a pipe, like a Southern Gentleman.

"If you'd wanted to see what the Wolf was really like, you'd have gone to Sylvio's," he growled.

"OK, is that an invitation? When shall I come, *now*?"

"Come next Sunday," Wolf replied.

"Okay, we've got a deal!"

So two weeks later, alone this time, I hauled all my gear into the famous West Side club and was met at the door by Hubert Sumlin, still smiling. He set me up with a huge tumbler of 100% bourbon and kept one eye on me throughout the evening.

Wolf did his stuff in the usual way, but made it clear he was conscious of the camera. The crowd was great, smoke and noise adding to the excitement.

Although Wolf himself set me up with another tumbler at half-time, I made it through the night with only a little damage to my VW on taking off for home. But the important thing was that the images of a great night were in the bag.

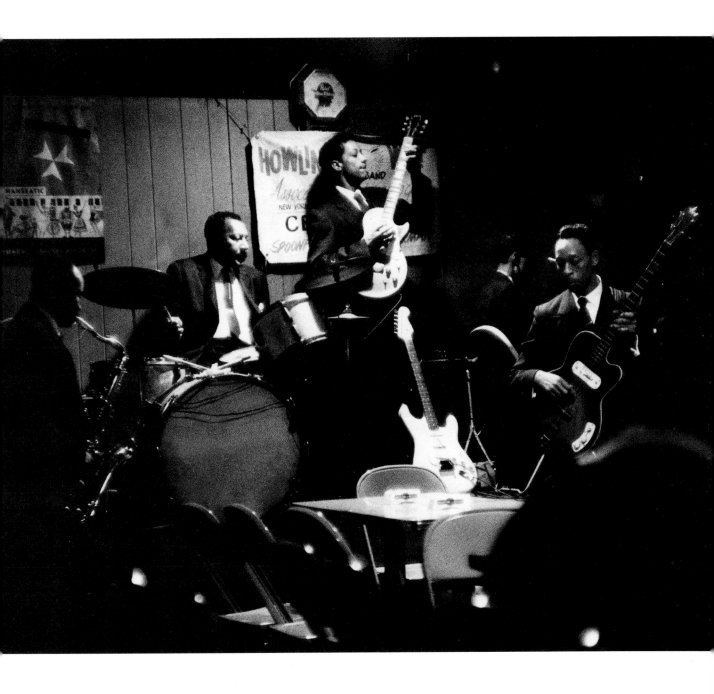

Hubert Sumlin, lead guitar; Johnny Jones,

piano; Willie Young, tenor; Andrew "Blue Blood"

McMahon, Kay-bass; Cassell Burrow, drums

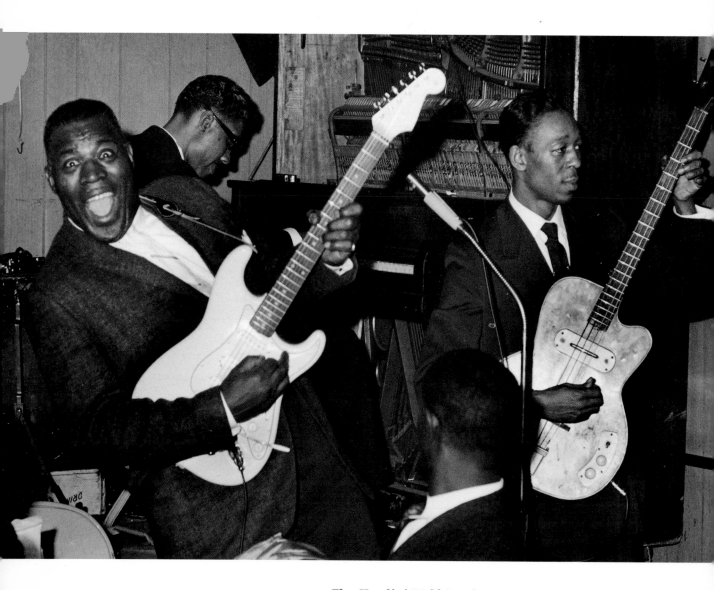

The Howlin' Wolf Band 1964

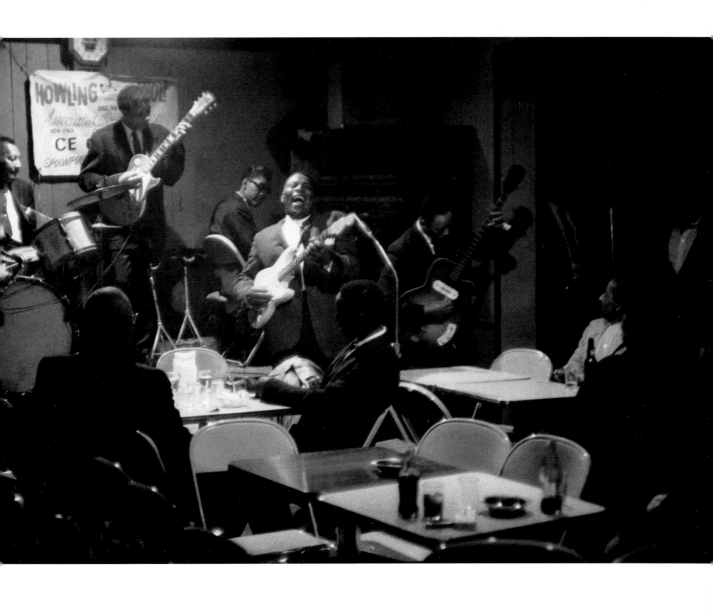

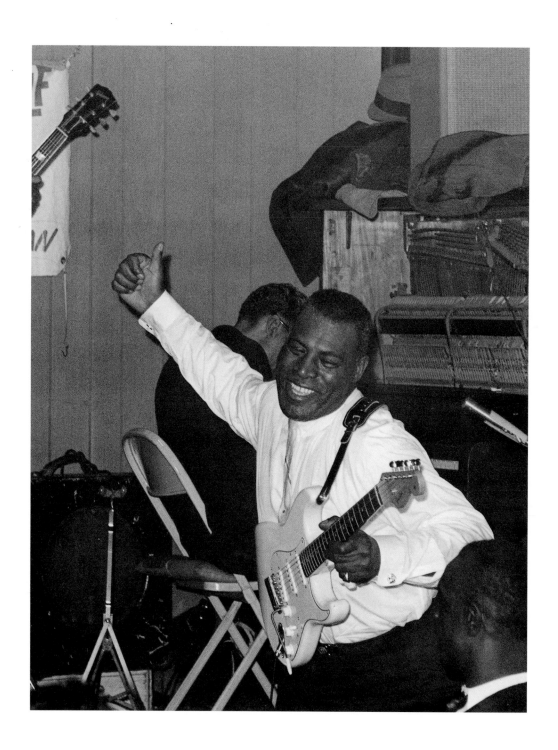

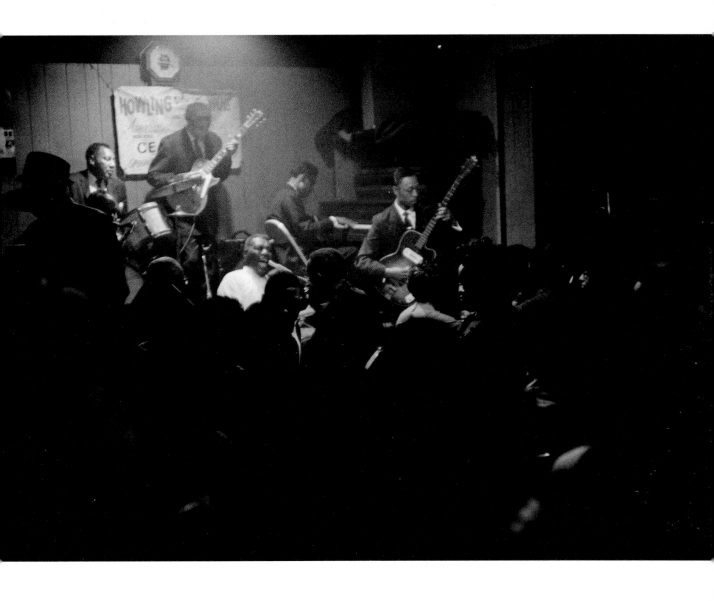

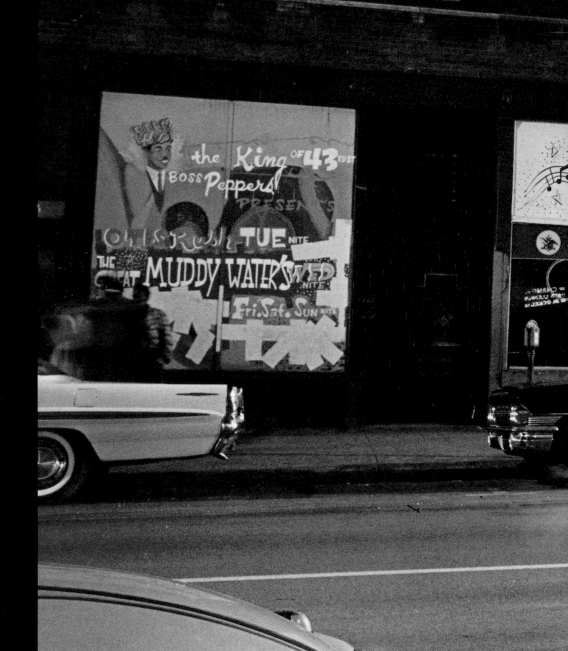

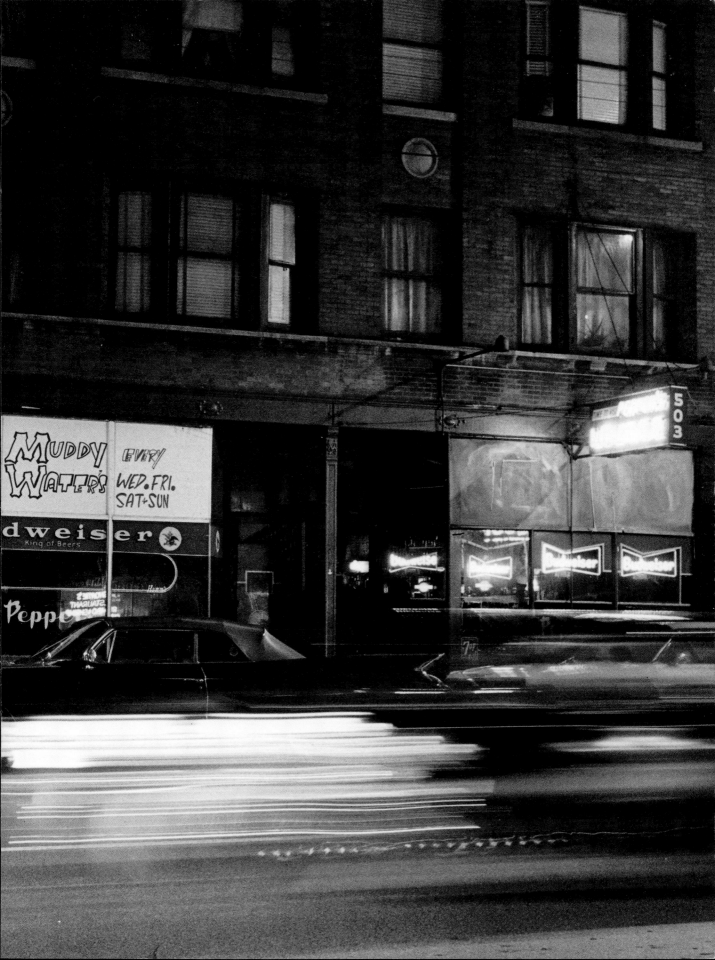

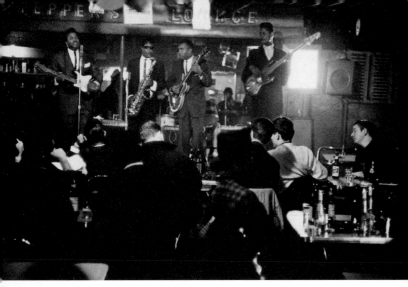

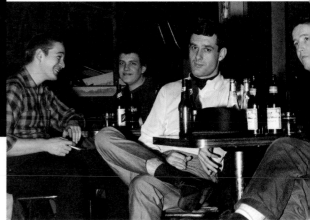

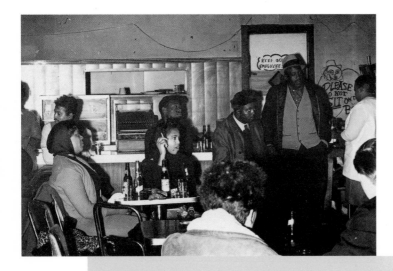

These photographs are from an Otis Rush appearance at Pepper's Lounge. In attendance were Charlie Musselwhite, Mike Bloomfield and Paul Butterfield, all of whom came to Pepper's frequently to catch either Otis Rush or Muddy Waters. Otis was very high on their charts. I didn't know him well, but in watching him interact with them he seemed like a very gregarious and helpful guy.

Charlie, Mike and Paul all went on to have major careers as musicians. This is the only time I ever photographed Charlie Musselwhite, although I knew him well and considered him a friend. "Memphis Charlie" credits a waitress at Pepper's named Mary with persuading Muddy Waters to listen to him play harp, an audition that launched Charlie's career.

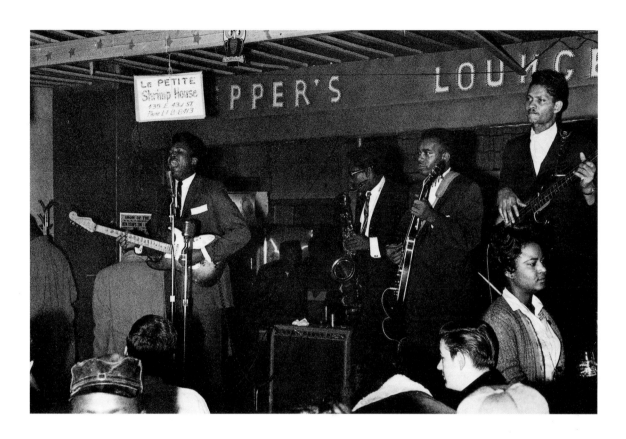

Otis Rush 1963

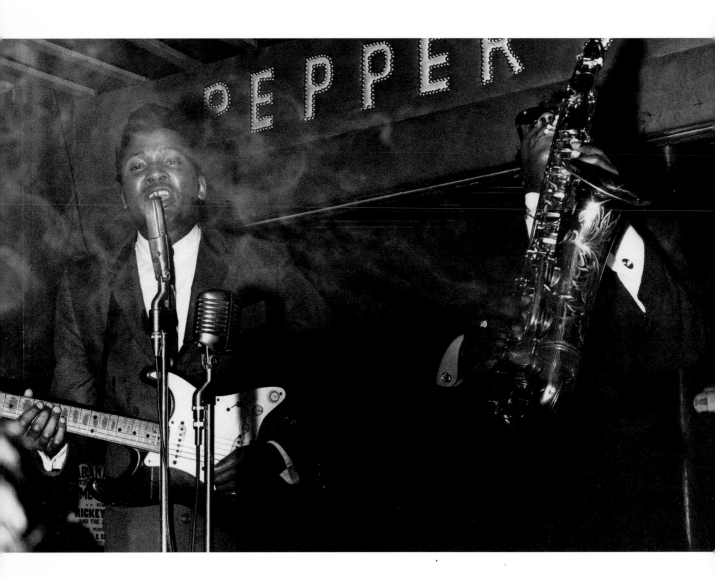

Otis Rush and Little Bobby 1963

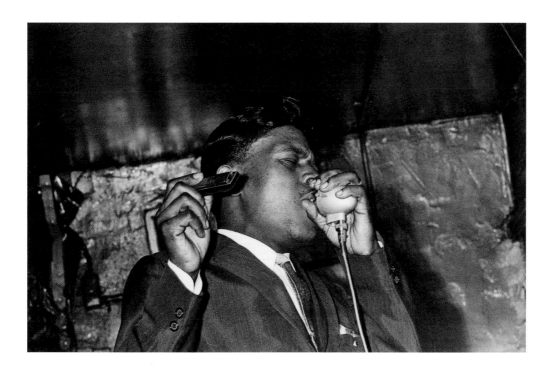

Jr. Wells 1965

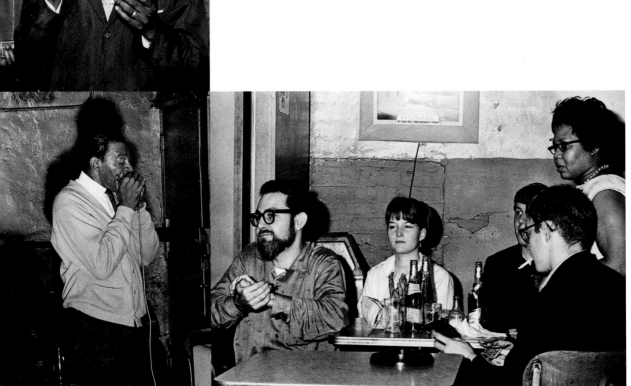

None of the blues clubs were luxurious but Theresa's was downright tacky. It was a tiny space in a basement, with exposed conduits and cracked walls, and always full of people.

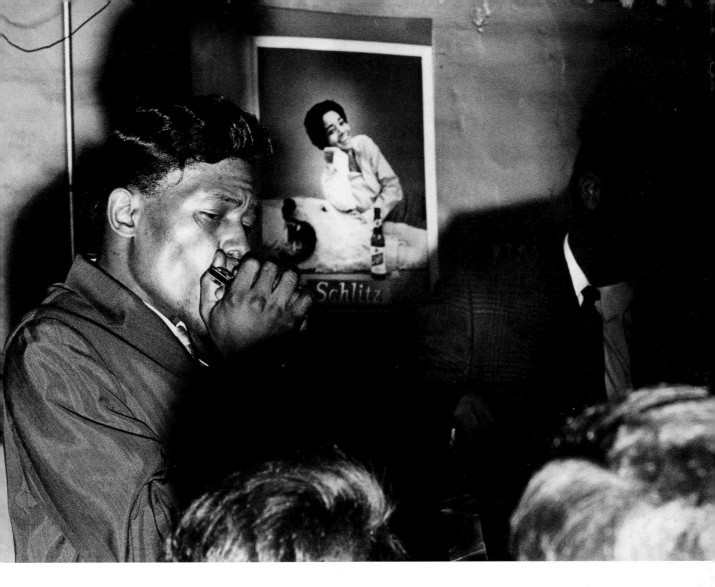

Jr. Wells 1965

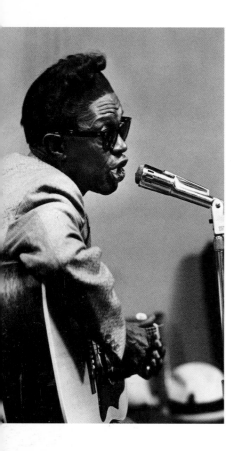

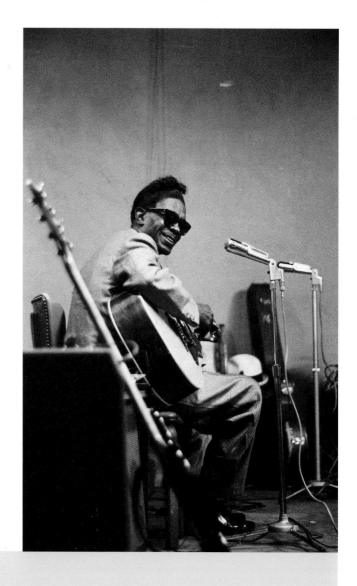

Lightnin' Hopkins was my kind of blues singer: a whole show in one neat package. With his heart-wrenching sounds of lamentation and complaint, leavened with poetic and often penetrating psychological insights, highlighted, decorated and translated by his magical guitar playing, nothing and nobody else was ever needed.

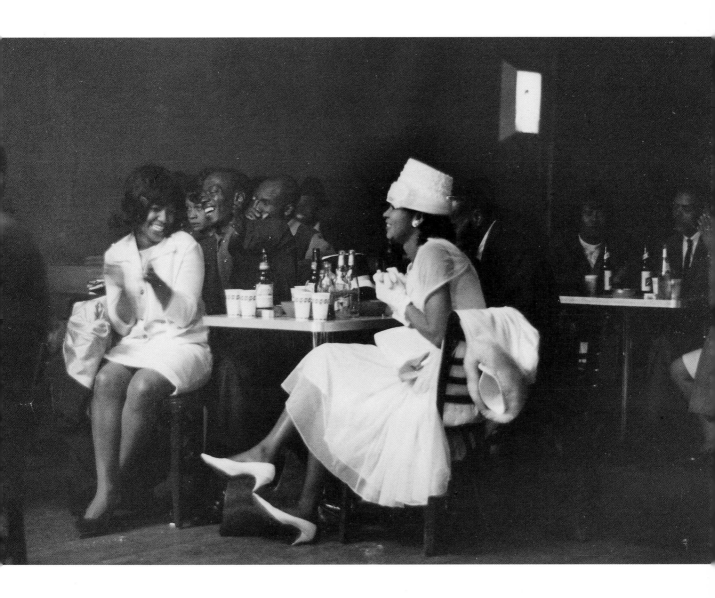

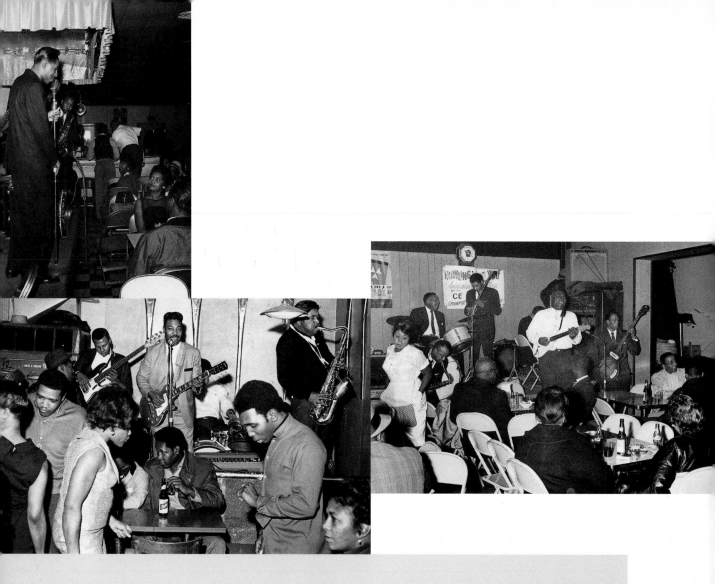

I often shot at North Side blues clubs like the Fickle Pickle and Big John's, where the audience was predominantly young and White. I also shot at Black clubs on the Southside and the West Side: Pepper's, Sylvio's, Theresa's, the Sutherland, McKie's. There was a difference.

You walked into the Black clubs and you were in a different world. You opened the door and the smoke hit you in the face. You couldn't see or breathe, and had to grope for a corner where you could catch your breath. As your eyes adjusted, you could see tables and people, and the musicians.

In a Black club, when the performers sang we were all in it together. You had had that experience, you had had that sorrow. You too had been conned and double-crossed, taken for a ride, had money troubles, been disappointed in love. You were part of the experience.

In the White clubs, as wonderful as some of the artists and their performances were, and however knowledgeable some members of the audience might be, the experience was different. Instead of telling *us* about *us,* they were telling *you* about *them*. The identification between the artist and the audience wasn't there.

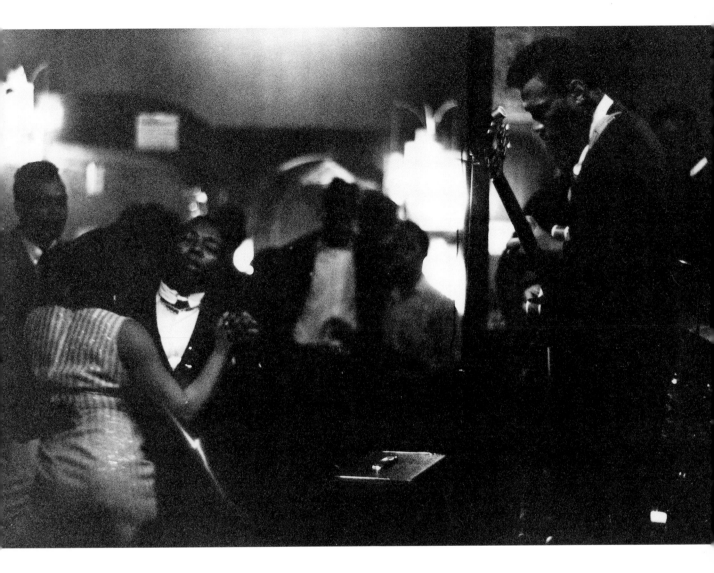

Magic Sam 1968

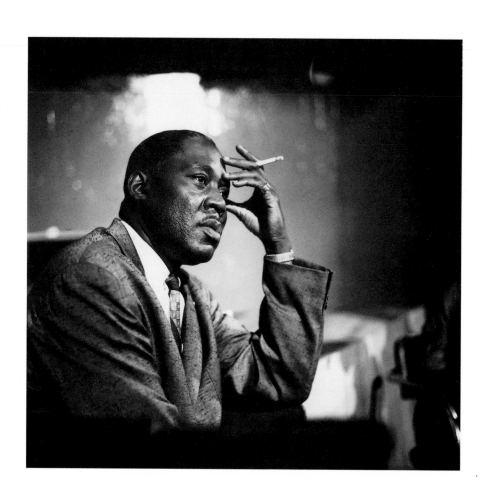

Memphis Slim 1959

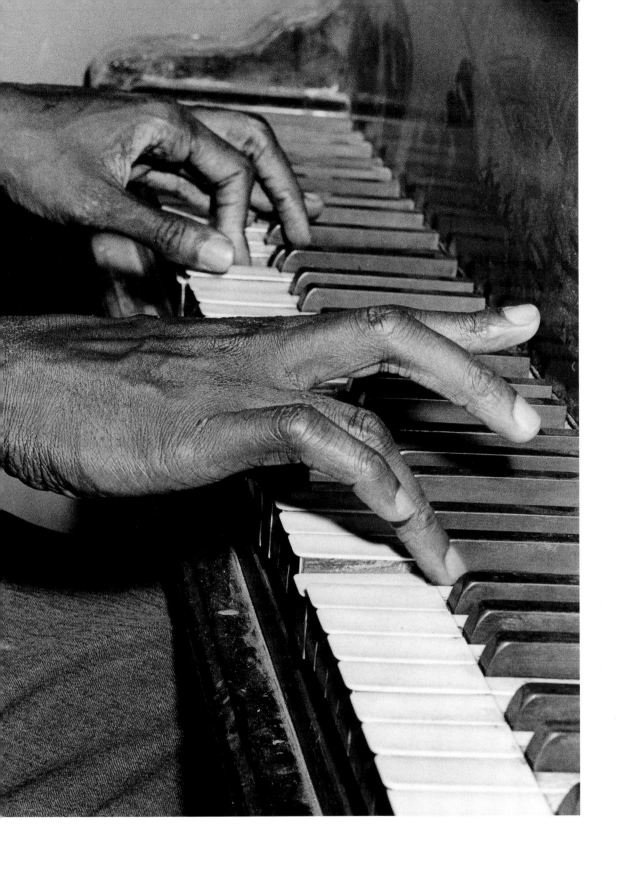

Memphis Slim was the perfect subject for my first blues job. Warm, friendly, urbane, cooperative, understanding—Slim was these things and more. I had the feeling of instant friendship.

He was living at the Pershing Hotel at that time—not performing there. But he had arranged for all the lights and "atmosphere" to be set up before I got there, and he spent an extended afternoon and early evening patiently performing for an audience of one—plus a photographer...

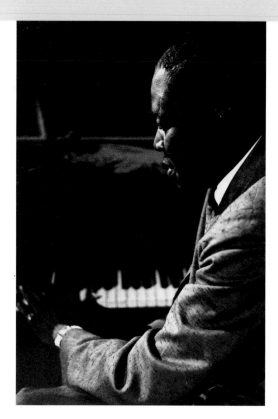 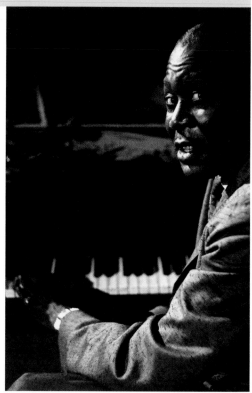

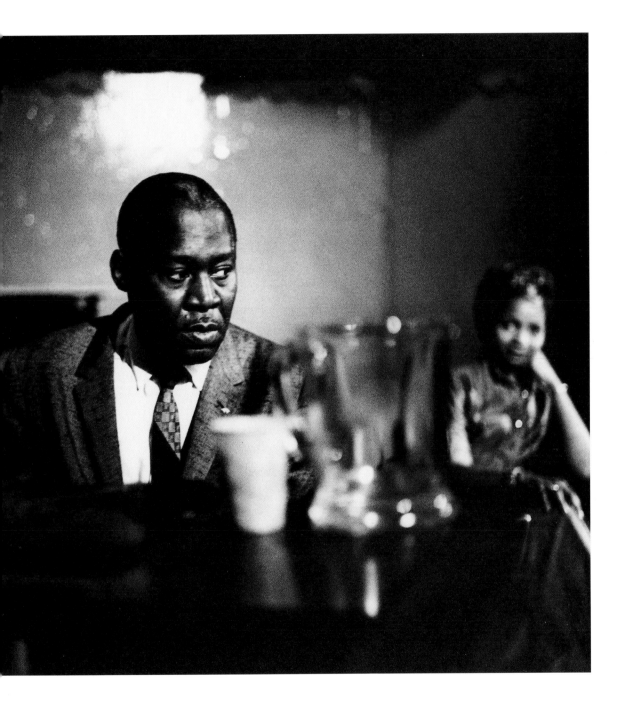

Memphis Slim 1959

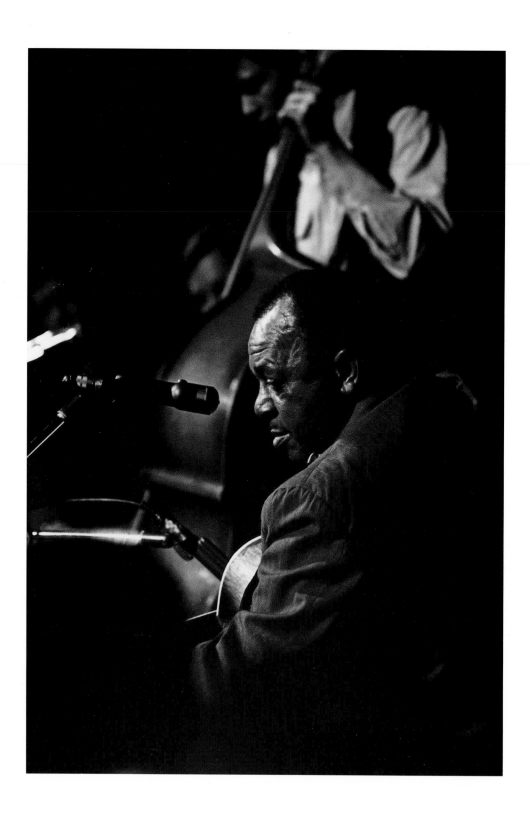

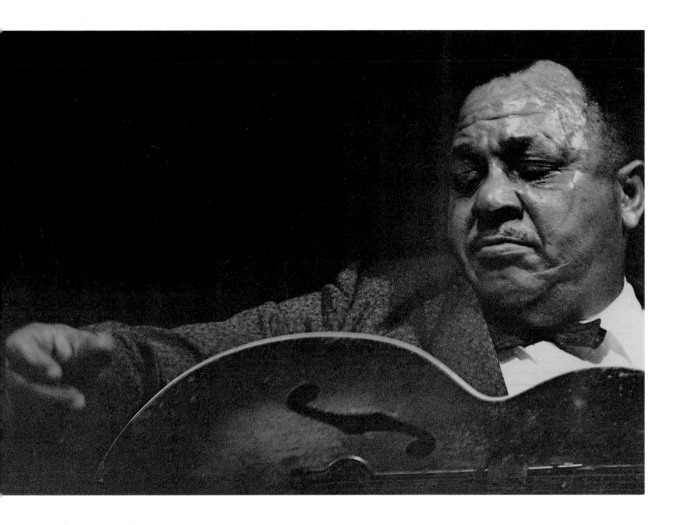

Big Joe Williams 1961

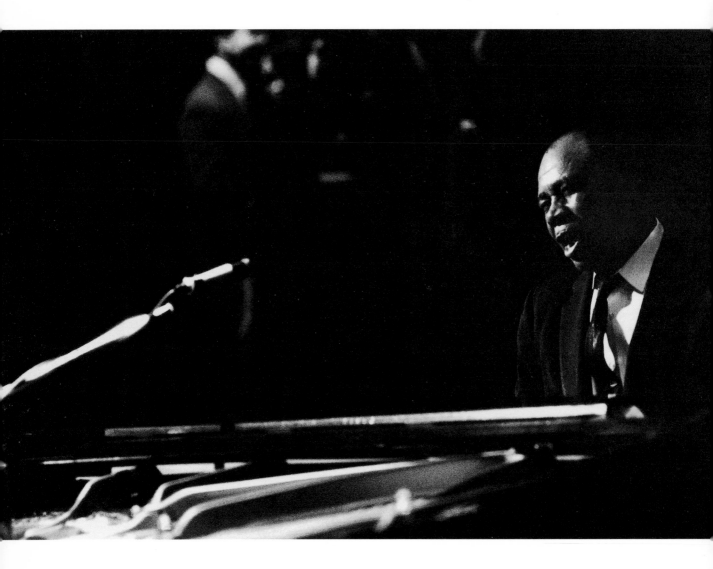

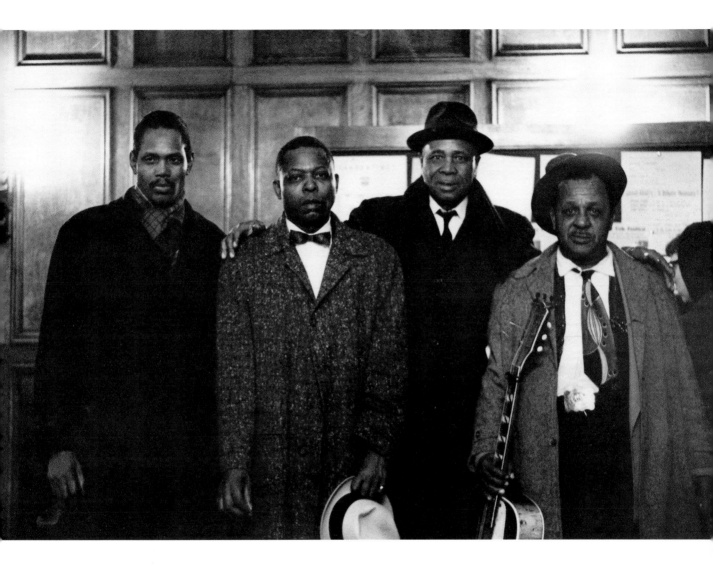

Big Walter Horton, Floyd Jones, Sunnyland Slim, Big Joe Williams 1962

Ransom Knowling 1961

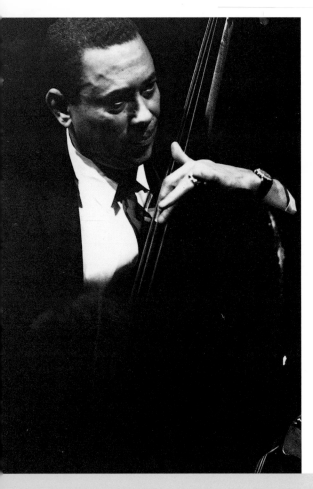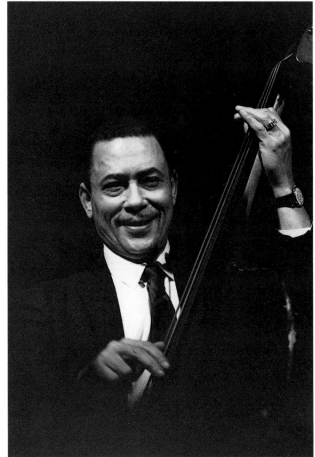

Ransom Knowling was one of the most popular sidemen in the blues. Handsome and personable, he added his special beat of his standup bass to jazz performers as well. His multiple talents kept him very busy, but according to pianist Erwin Helfer, Knowling was working toward mastery of classical techniques as well.

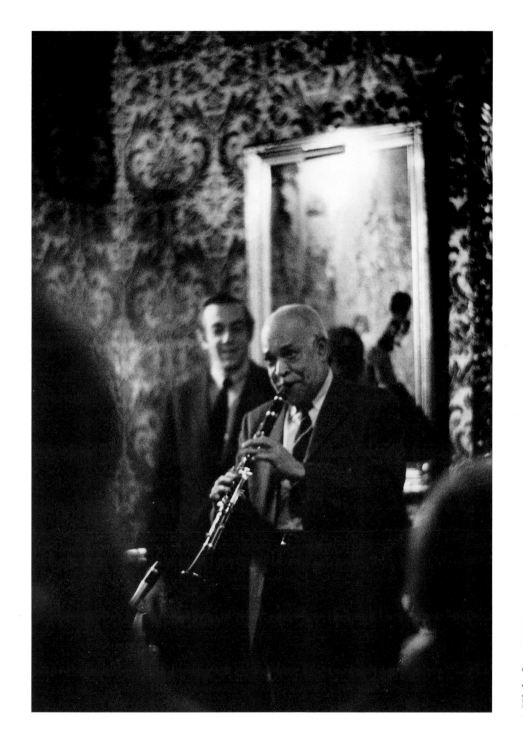

Albert Nicholas 1963

Little Brother Montgomery 1962

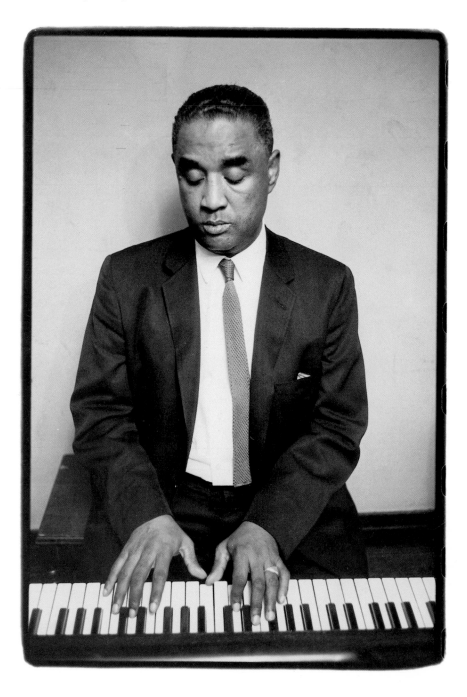

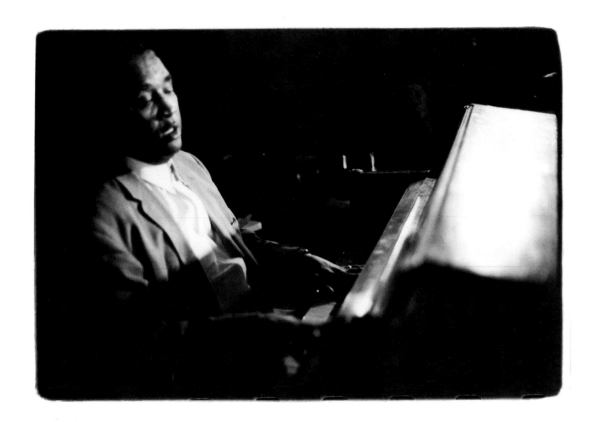

This shot is special to me.

Although I knew Little Brother for many years, took many photos of him and interviewed him as well as producing one of his Folkways albums, I rarely photographed him in actual performance. In the recording studio, Brother tended to be stiff and self-conscious when the camera was clicking. But this early performance shot, with its strangely soft lighting and diffused focus, captures his essence, his sincerity, more than any other. It projects the real Little Brother. The negative was lost for many years and its rediscovery was for me a cause for celebration.

This is the way I like to remember him.

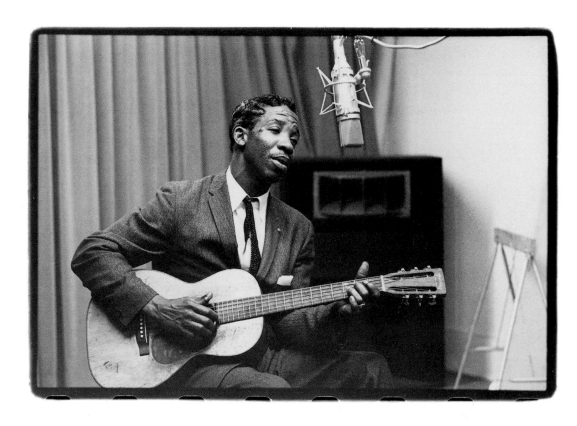

Maxwell Street Jimmy 1965

A sartorially-enhanced St. Louis Jimmy showed up for the Testament recording session in 1965. When my prints came back, Pete Welding decided Jimmy looked too slick for the cover photo. Pete had lined everything up himself, but I had to take the fall. Pete used his own dressed-down photo taken after the fact. Consequently, this is the first time the "commissioned" photo has ever appeared.

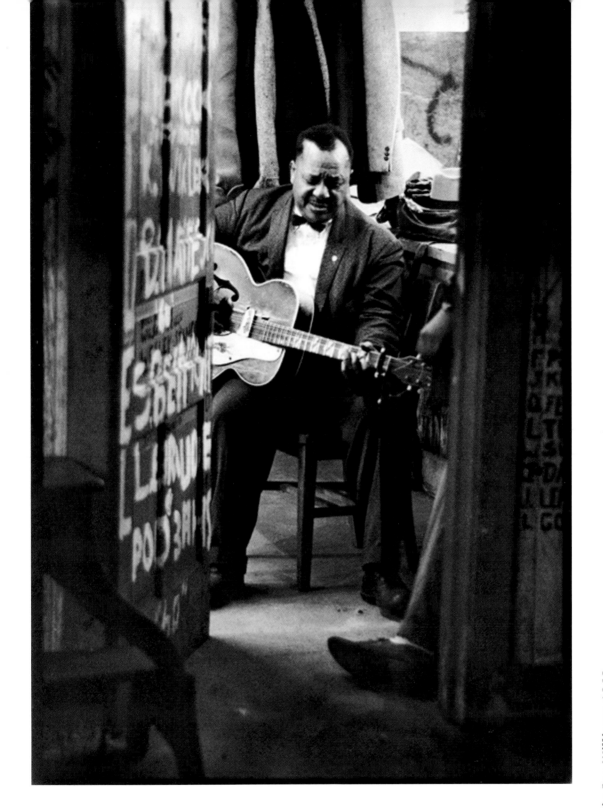

Big Joe Williams 1962

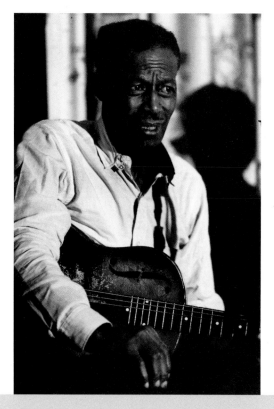
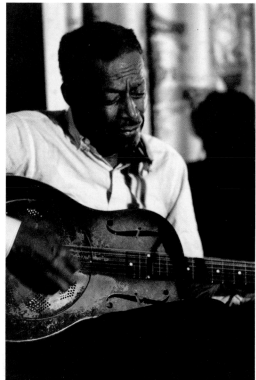

The most deeply affecting blues performance I ever attended was Son House's at the University of Chicago in 1964. Okay, he was over the hill. But as he sat there alone on a rickety chair holding his steel bodied guitar, he underwent a total metamorphosis in front of your eyes.

After a brief ingratiating smile, his face changed dramatically. First slowly but then swiftly as the lyrics changed he projected those terrible moments that haunted his memory.

When he sang "Death Letter Blues," he saw his dead girlfriend "lying on the cooling board," and it made your own blood run cold. The scene was reflected in his face, sounded in the violent guitar strokes and his painfully forced voice. *Unforgettable!*

When he was in Chicago for his 1964 appearance at the University of Chicago, House visited Pete Welding at Pete's home in Hyde Park.

Pete decided to get House's reaction to a recording of his own songs by one of the up-and-coming young White blues pretenders.

House was obviously pleased to hear someone else on a recording of his songs, but his judgment was simple and devastating.

"Those are my words all right, but it sure ain't my music."

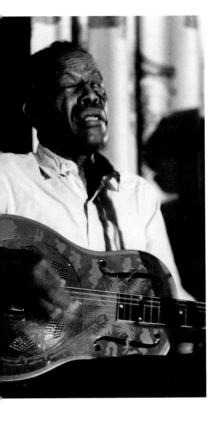
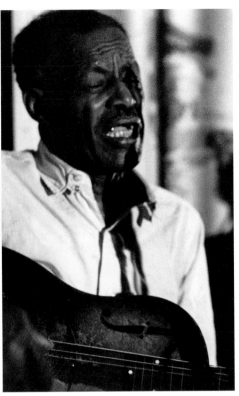
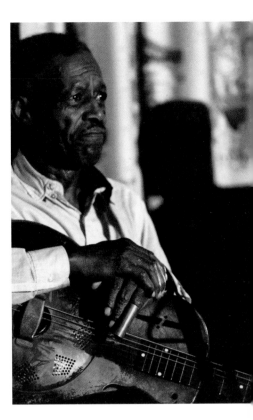

Son House 1964

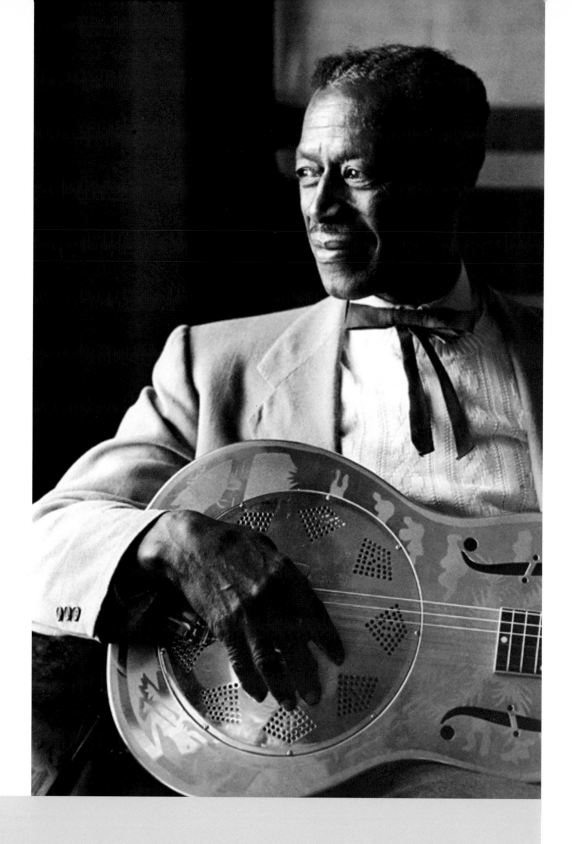

Son House was the greatest of all blues guitarists, according to Muddy Waters, but by the time of his rediscovery in 1963 he had sold his guitar and no longer played. He had actually been a major influence on the legendary Robert Johnson.

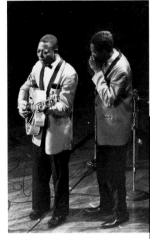

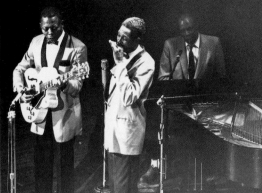

Floyd Jones, Big Walter Horton, Sunnyland Slim 1962

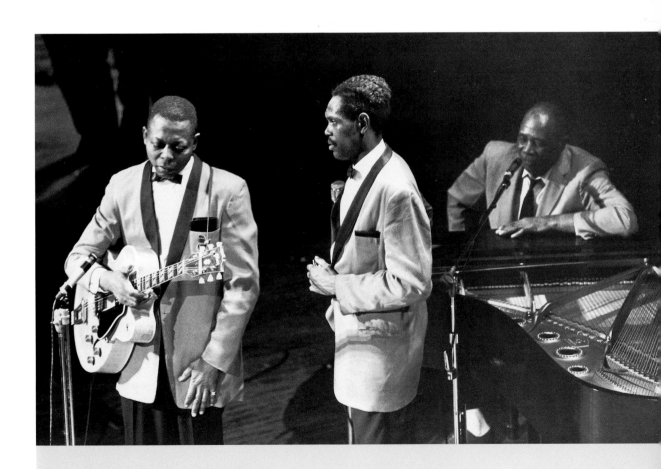

Although Sunnyland Slim remains at the piano in the background, you can sense his protective arm around

Floyd Jones and Big Walter Horton performing at the front mike.

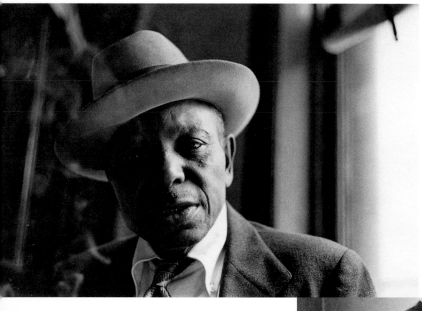

Jazz Gillum played with Big Bill Broonzy in the '30s. Gillum always maintained that he, Gillum, wrote

"Key to the Highway," after the infamous Lester Melrose asked him to write "a highway song." It is

undisputed that Gillum recorded it before Broonzy. As Gillum told it, Melrose switched authorship to

Broonzy for his own purposes. Jazz was convinced to the end that no one could perform it like he did,

with what he called "the rise and fall" of his harp.

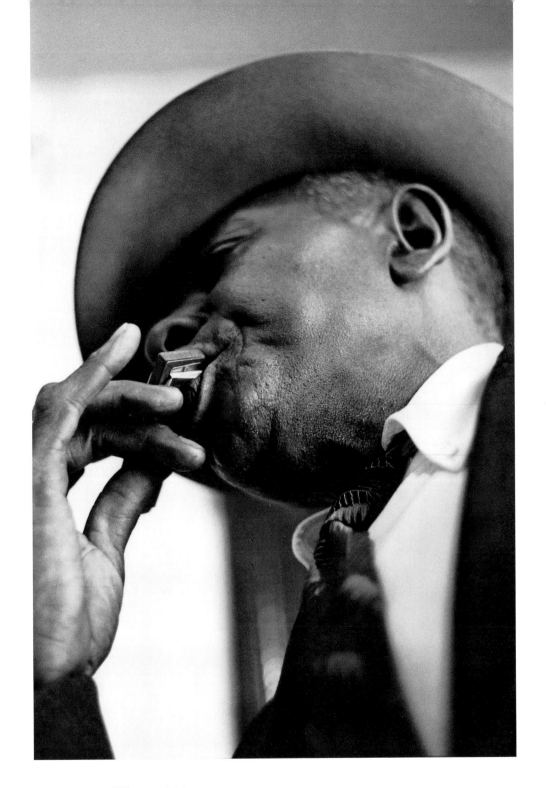

Jazz Gillum 1962

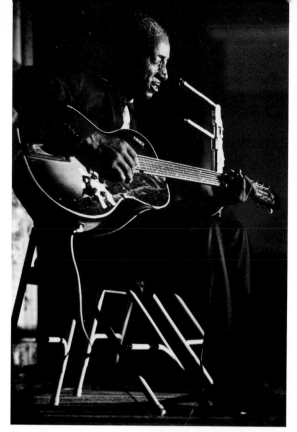

Mississippi Fred McDowell 1966

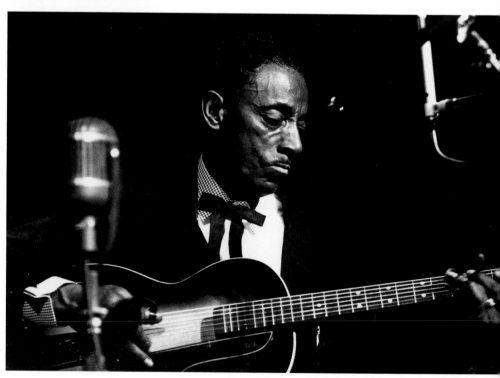

Bukka White 1968

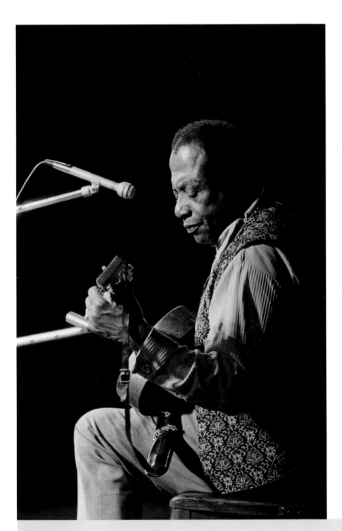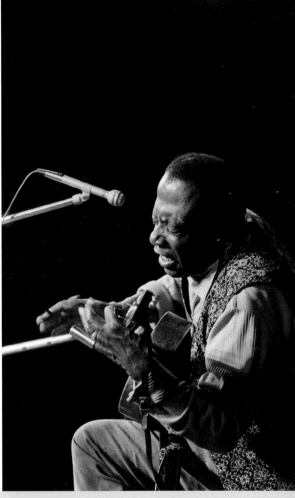

Bukka White's expression here has always reminded me of a line from one of his songs: "I don't mind dyin'

but I hate to see my children cryin'..."

Odetta 1959

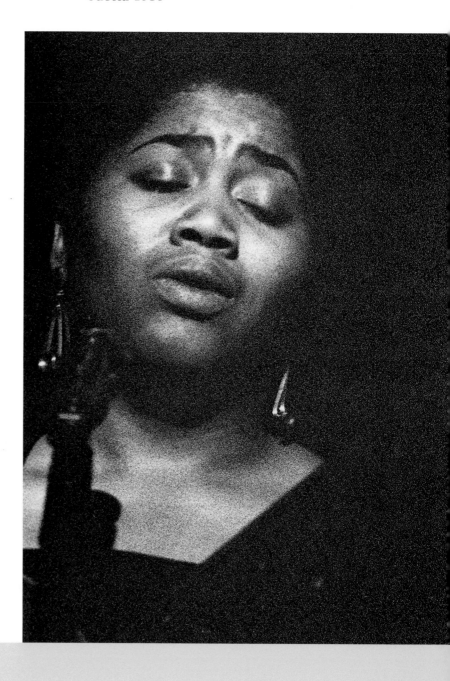

Odetta was one of the first artists I photographed extensively, and several images were published locally in the early '60s. I was familiar with her rich voice and tragic style from the *Tradition* LPs I was promoting at the time, and I featured her *"'Buked* and *Scorned"* frequently on my *Folk City* broadcasts.

Robert Nighthawk with Little Walter 1964

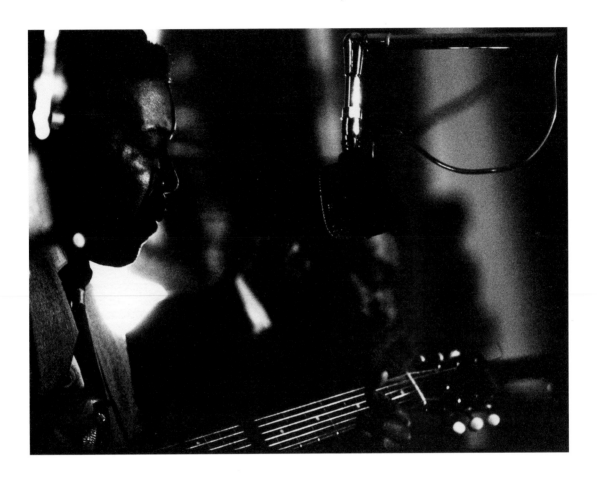

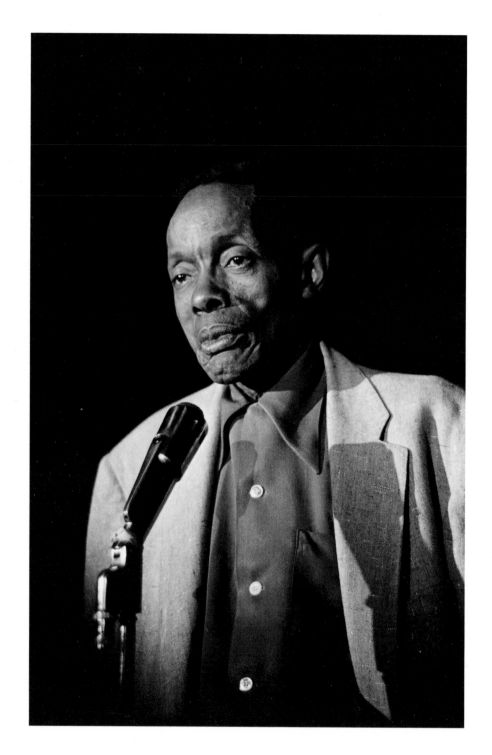

St. Louis Jimmy 1963

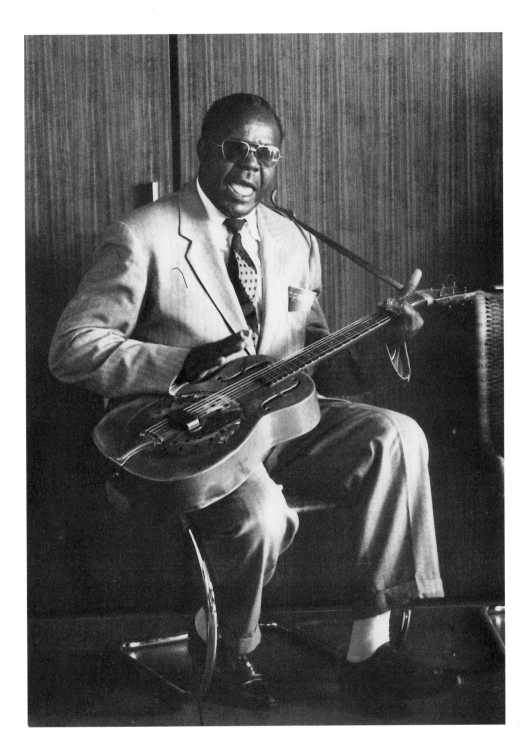

Arvella Grey 1962

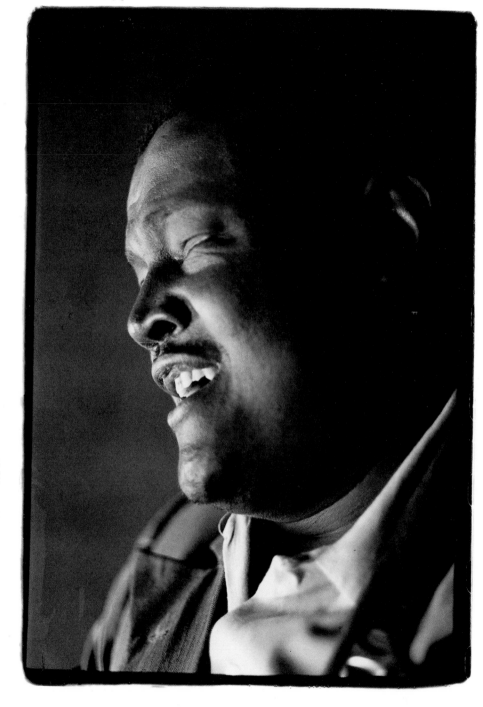

Blind James Brewer 1961

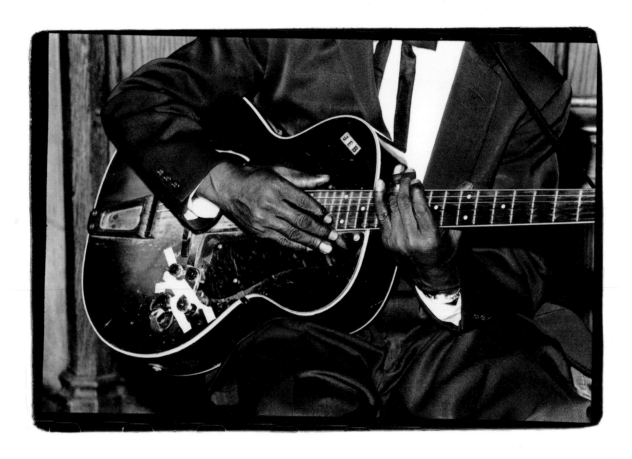

Mississippi John Hurt 1965

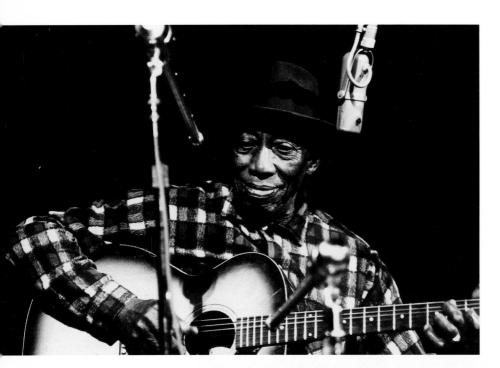

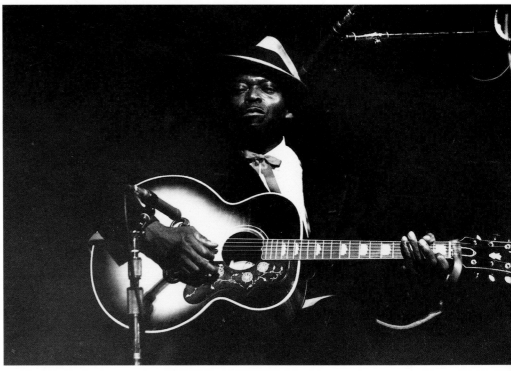

Robert Pete Williams 1965

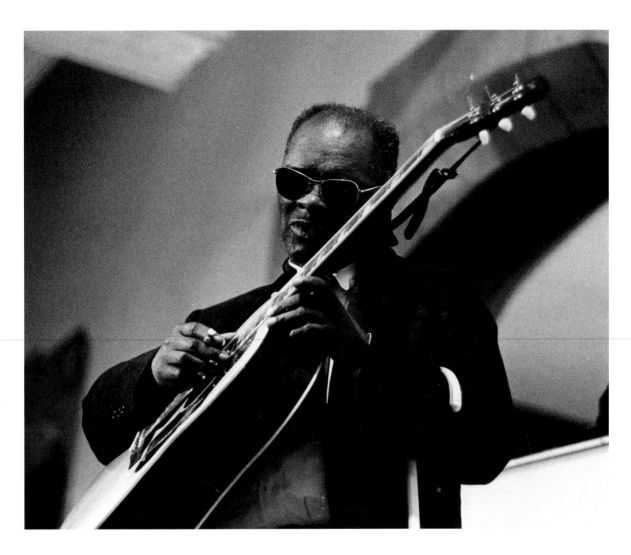

Reverend Gary Davis 1962

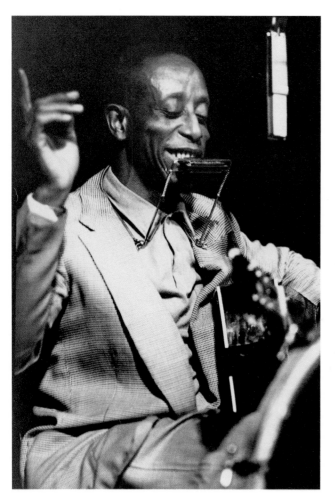

Dr. Ross 1965

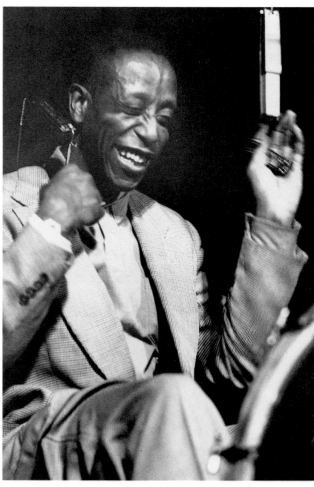

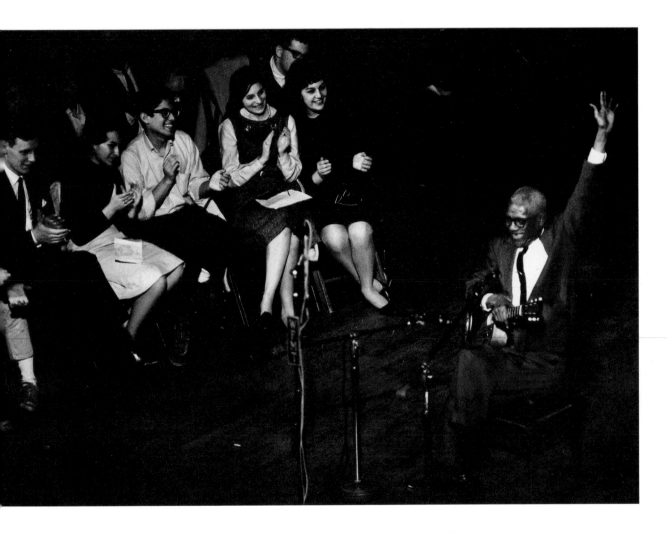

Furry Lewis 1964

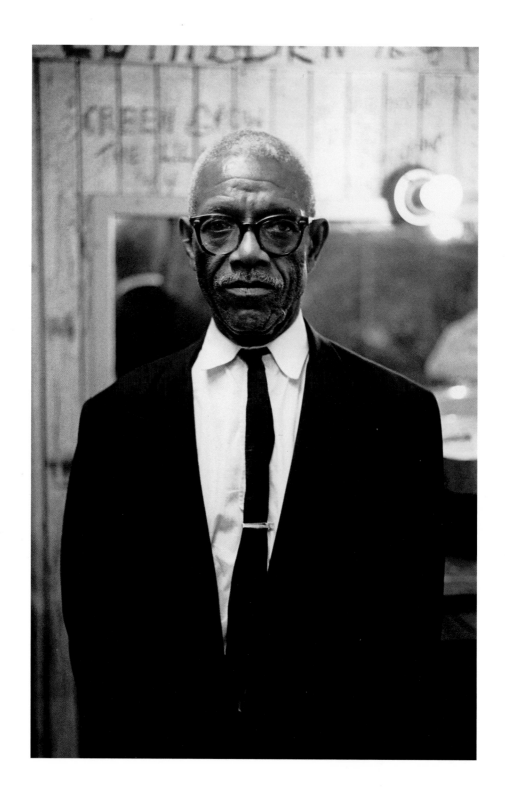

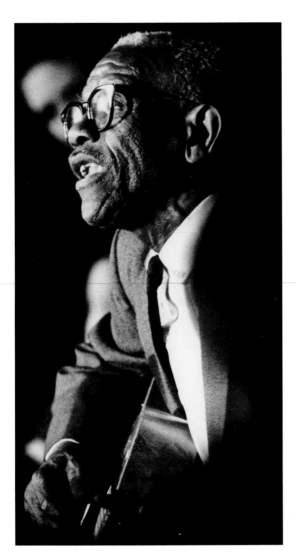

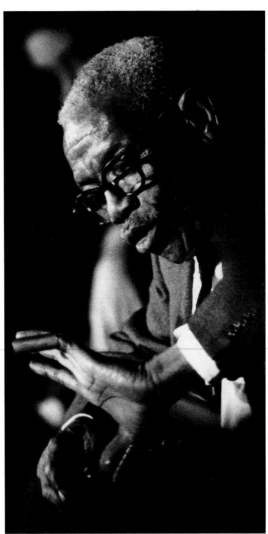

Furry Lewis 1964

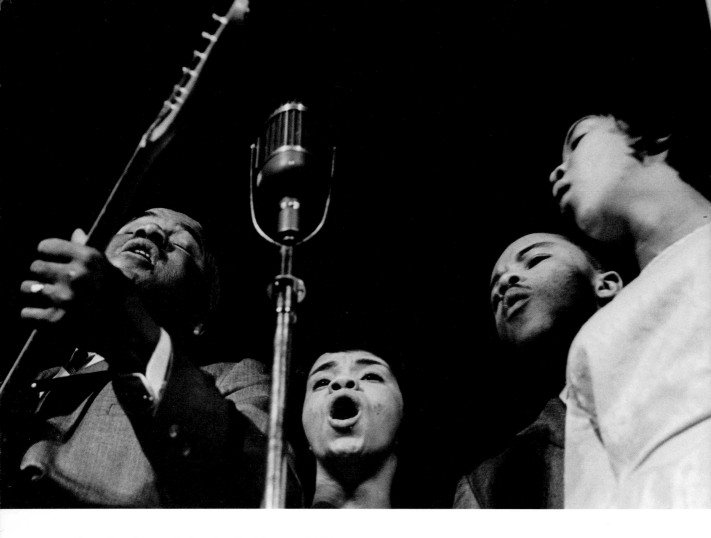

Pops Staples and the Staple Singers 1962

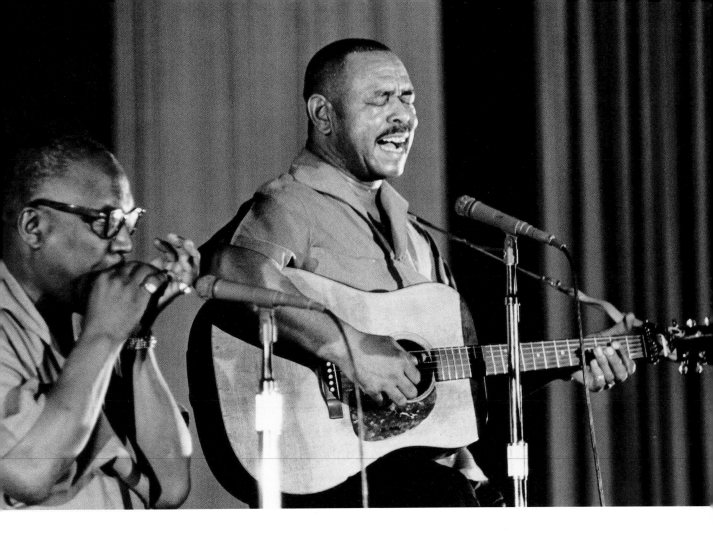

Sonny Terry and Brownie McGhee 1966

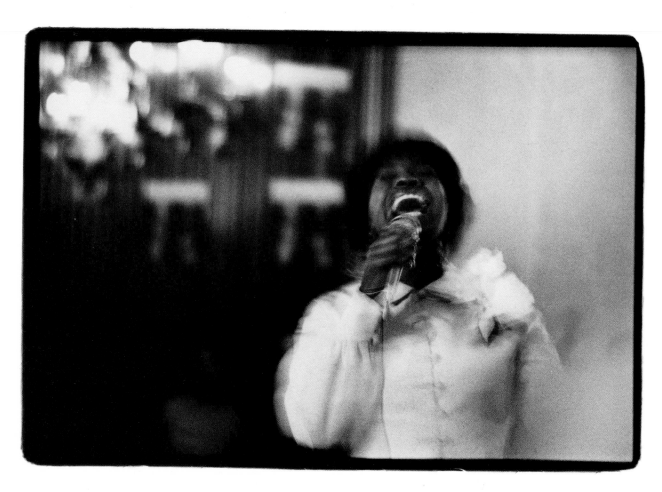

Little Esther Phillips 1970

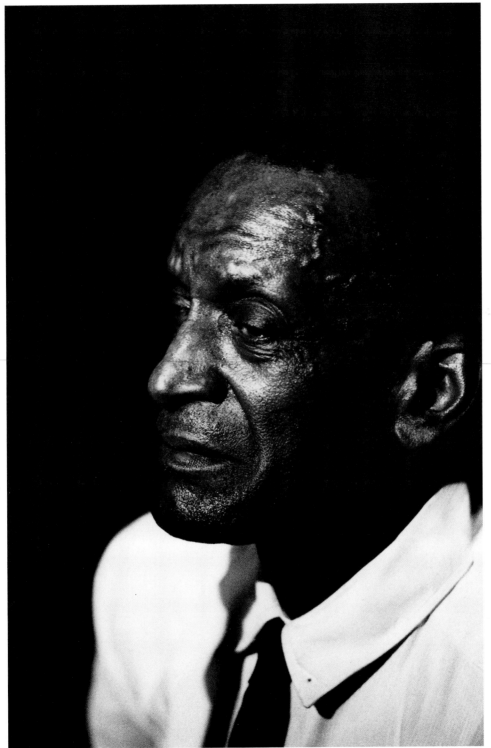

Sleepy John Estes 1963

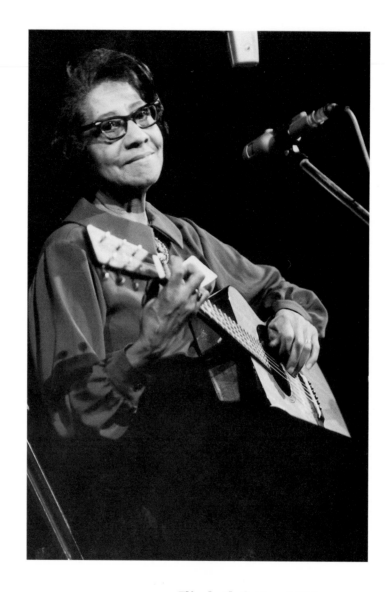

Elizabeth Cotten 1962

Josh White 1962

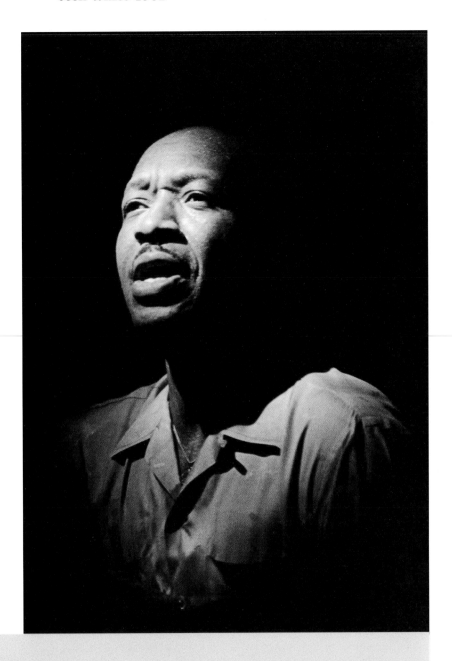

Josh White was the only blues artist I interacted with during both the People's Songs days (1946 et seq.) and the photography days (1959 et seq.). During the McCarthy era, Josh distanced himself from his old associates, including Paul Robeson, People's Songs and others who operated under a cloud of suspicion; so I didn't chat with him in 1962 at the Gate of Horn, although in the old days he had signed himself, "Your Buddy."

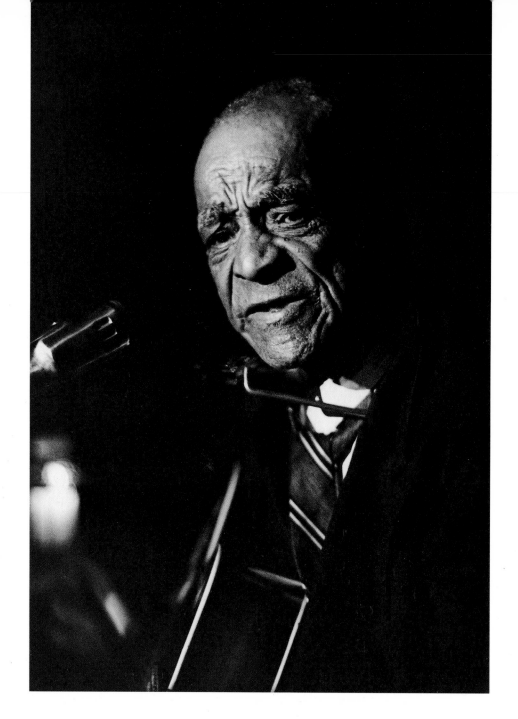

Daddy Stovepipe 1963

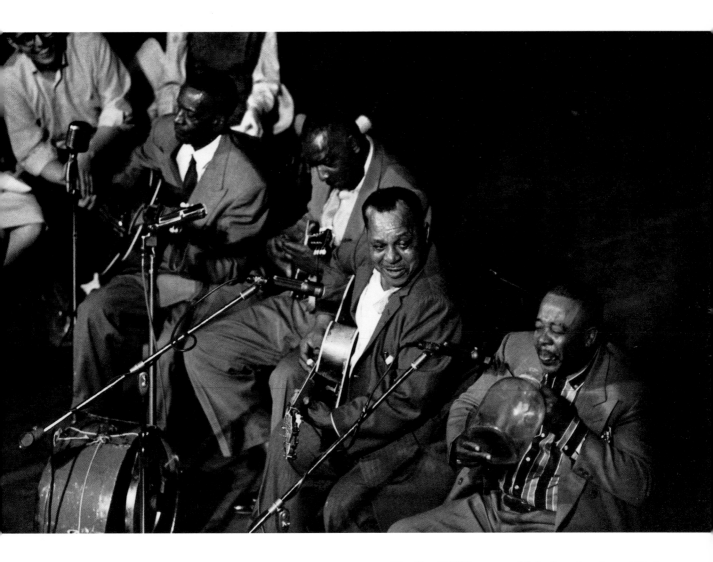

Big Joe Williams and his Jug Busters 1964

Muddy Waters and James Cotton 1965

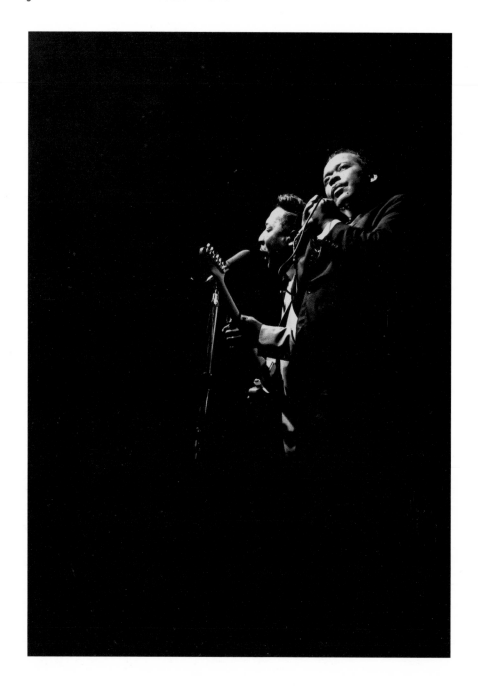

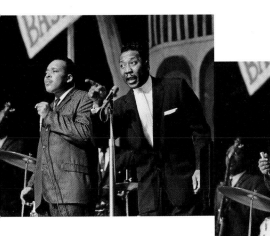

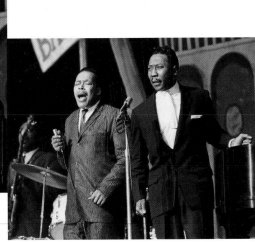

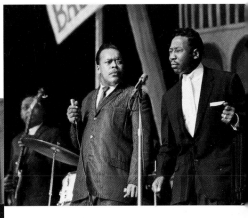

Whenever I think of Muddy Waters I always catch myself smiling. I remember his mock-threats in "Got My Mojo Workin'," wagging his head until his lips shook, B-B-B-R-R-R-R-R, and the crowd would erupt in response. I remember his easy camaraderie, his man-to-man friendliness, as well as his lethal charm with a pretty woman. I remember his easy smile as we chatted about Old Fitzgerald bourbon, and his admiring comments when he spoke about other musicians, even rivals.

Muddy was very supportive of other musicians. He brought many top artists up through the ranks in his band: harmonica players, guitar players, bass players, everything. If you listed all the people who came up through Muddy's band you would have a small directory of top musicians.

If a down-and-out musician hit town, Muddy would not *send* someone across town to help the person. He'd go *himself,* with extra money in his pocket and a bag of sandwiches. Muddy remembered that we are all part of the same vibrations. Not many people do.

Whenever I think of Muddy, I catch myself smiling. He was a great guy to know.

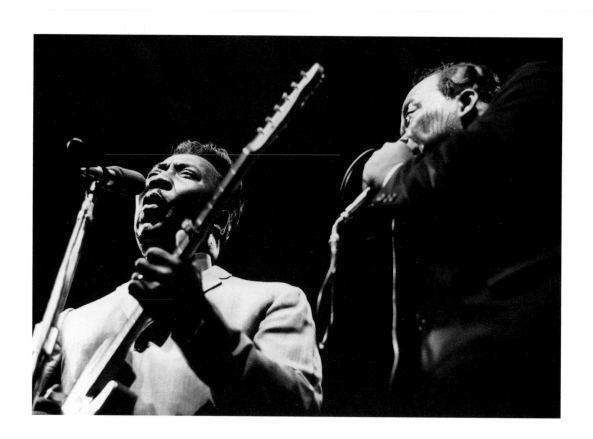

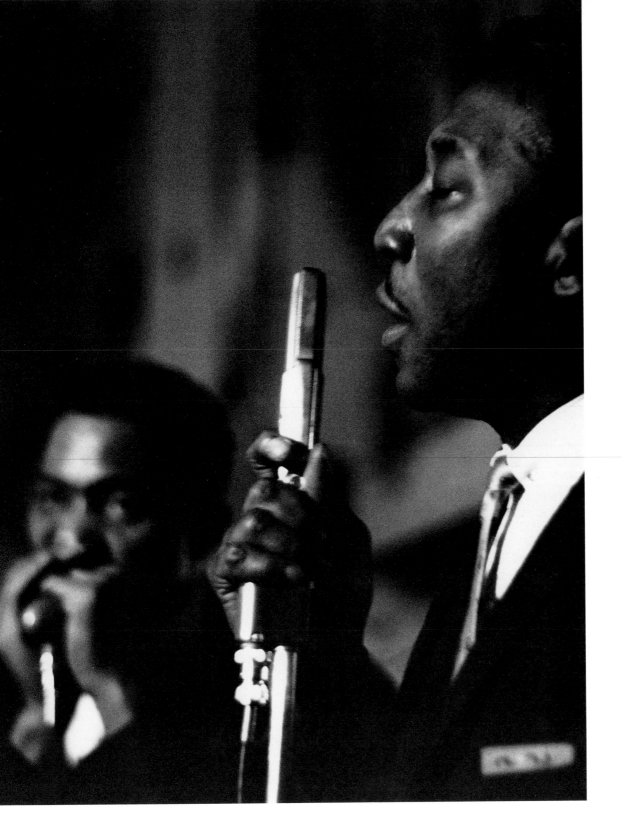

Muddy with Mojo Buford 1961

Al Grey, Dizzy Gillespie, James Moody, Muddy Waters 1965

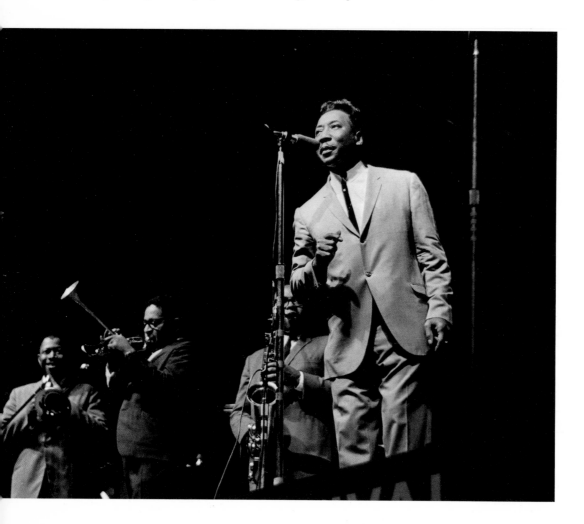

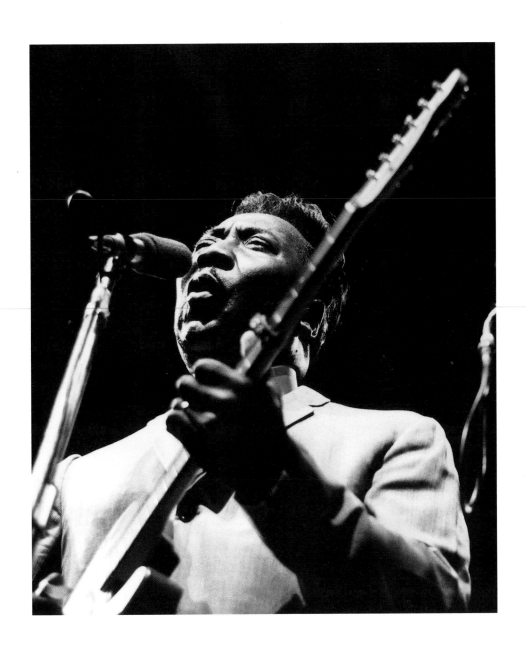

James Cotton 1965

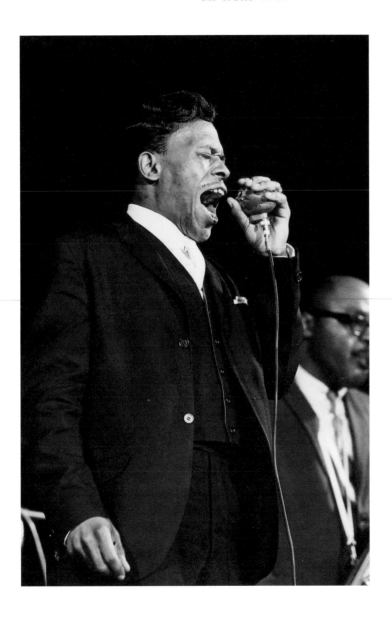

In 1969 at the University of Chicago's Mandel Hall they had a show called "Modern Chicago Blues Styles." There was an astonishing array of talent: Little Walter, Big Walter, Jr. Wells, Buddy Guy and others, all really cookin'.

Little Walter was absolutely carried away that night. He performed like a man possessed, he was just in ecstasy. I have never seen another performer as happy with himself and the response he was getting as Walter was that night.

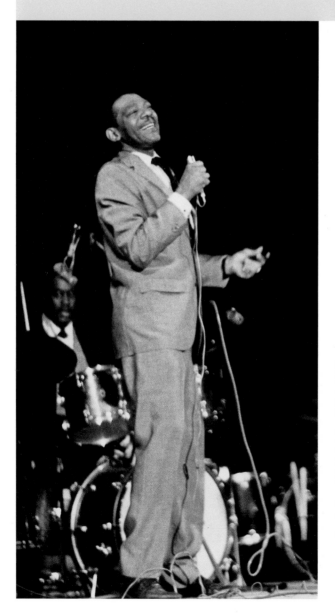

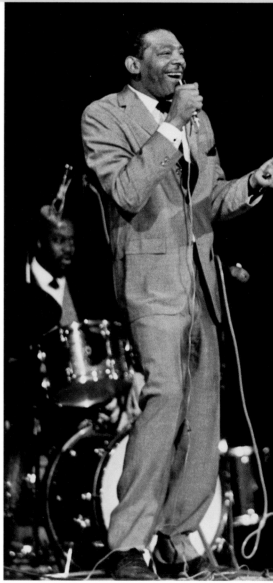

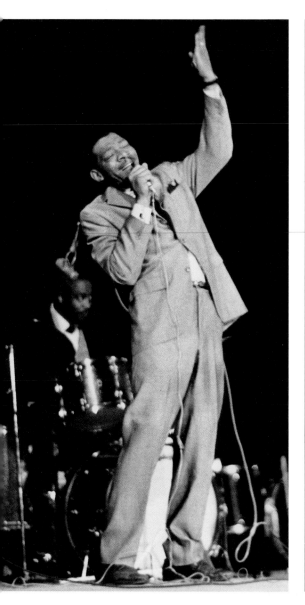

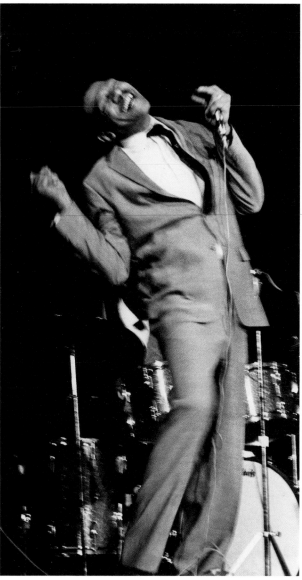

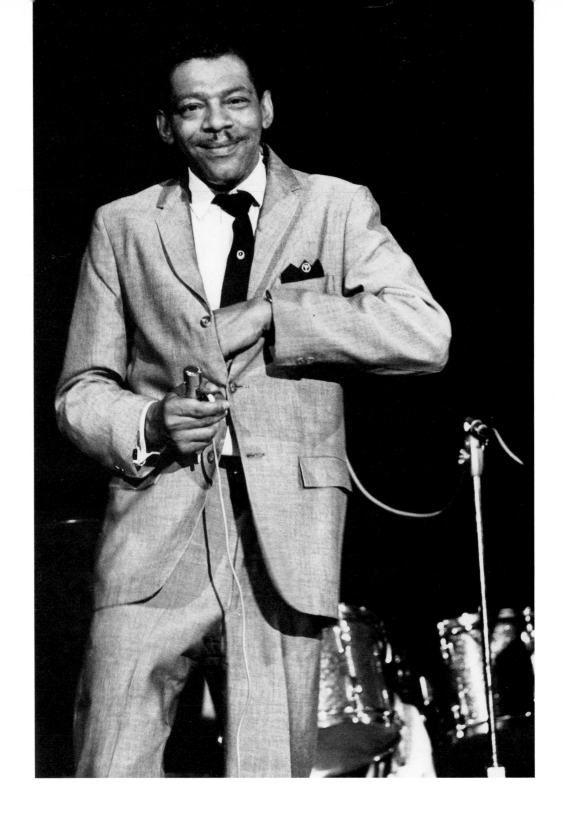

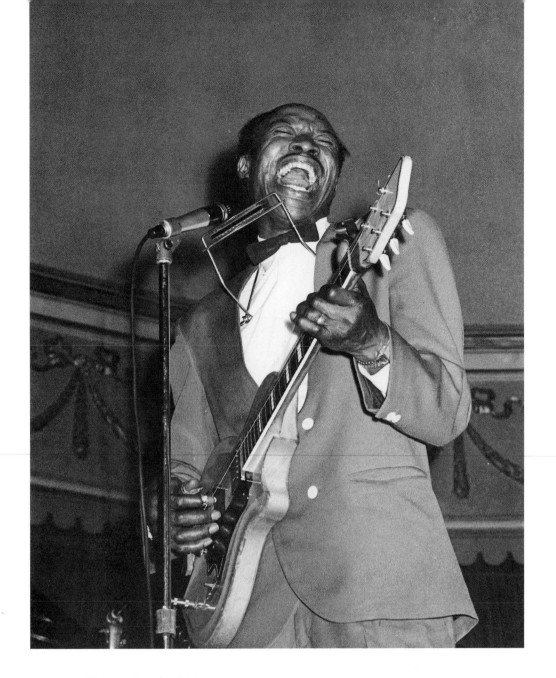

Jimmy Reed 1964

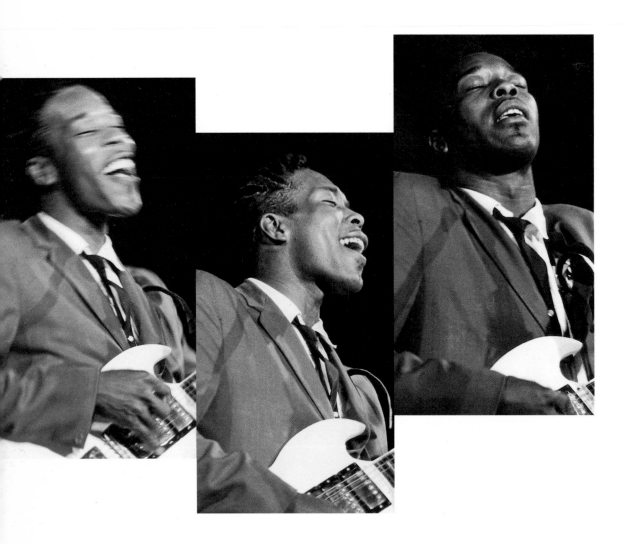

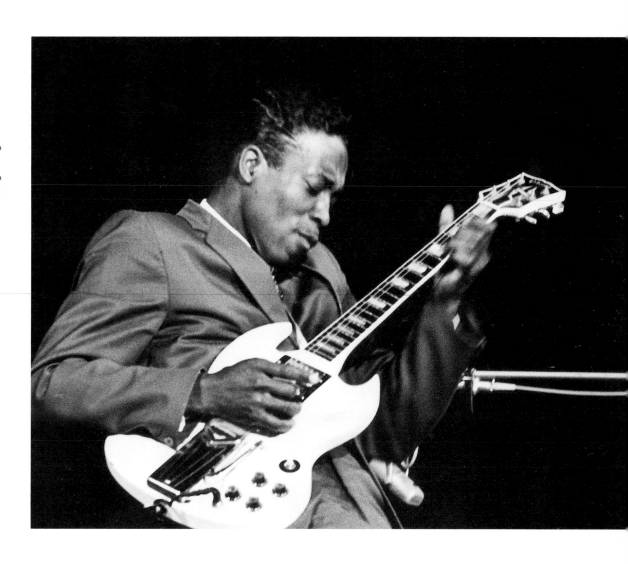

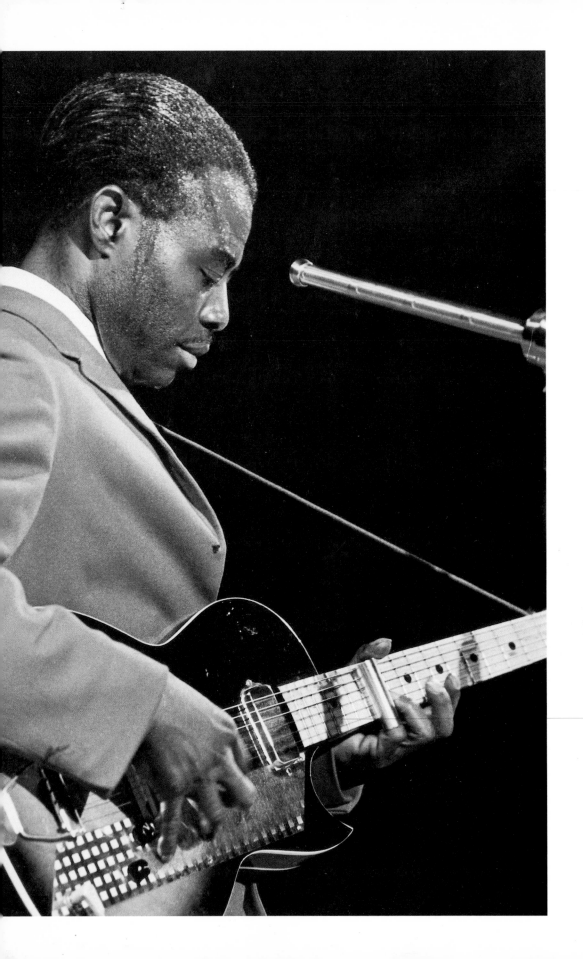

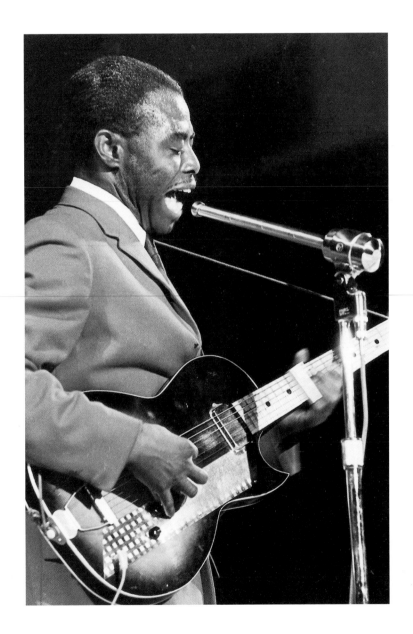

J.B. Hutto 1966

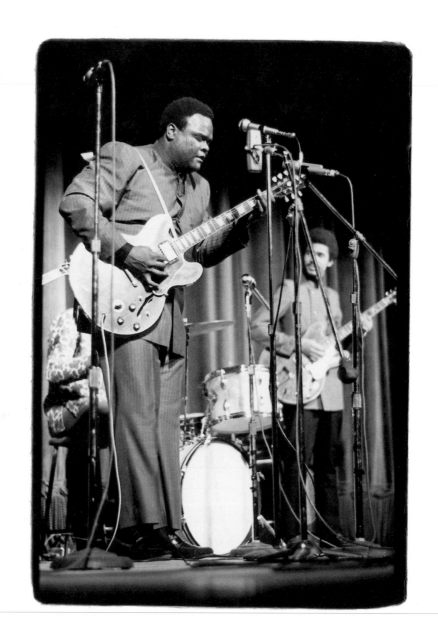

Freddie King 1966

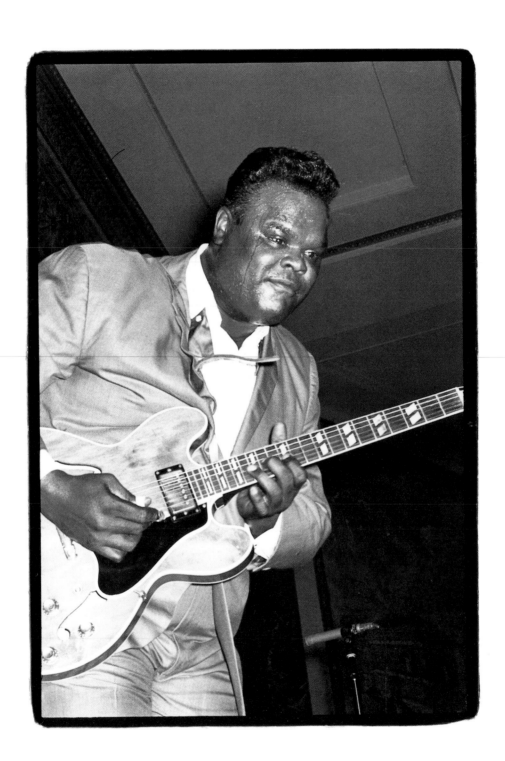

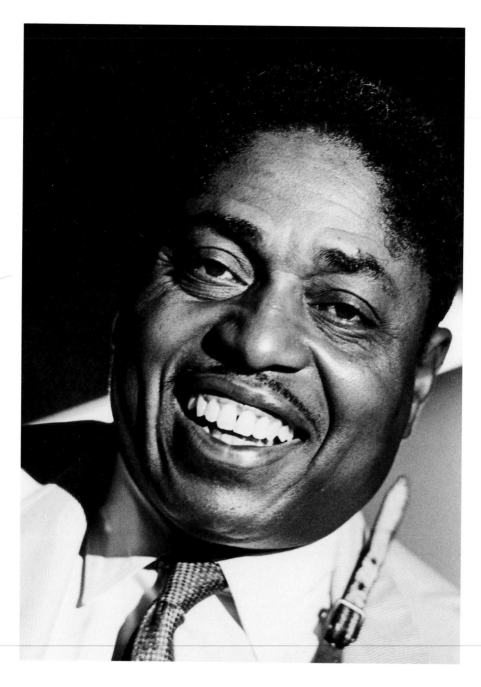

Johnny Shines 1966

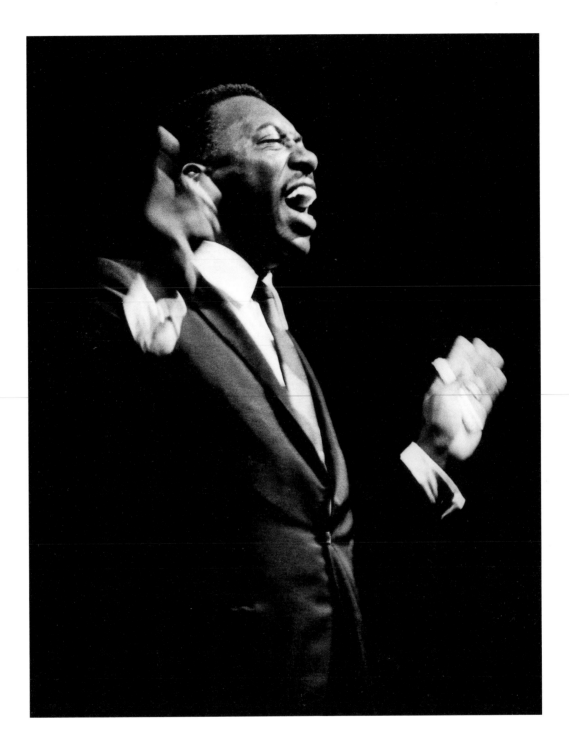

Joe Williams 1965

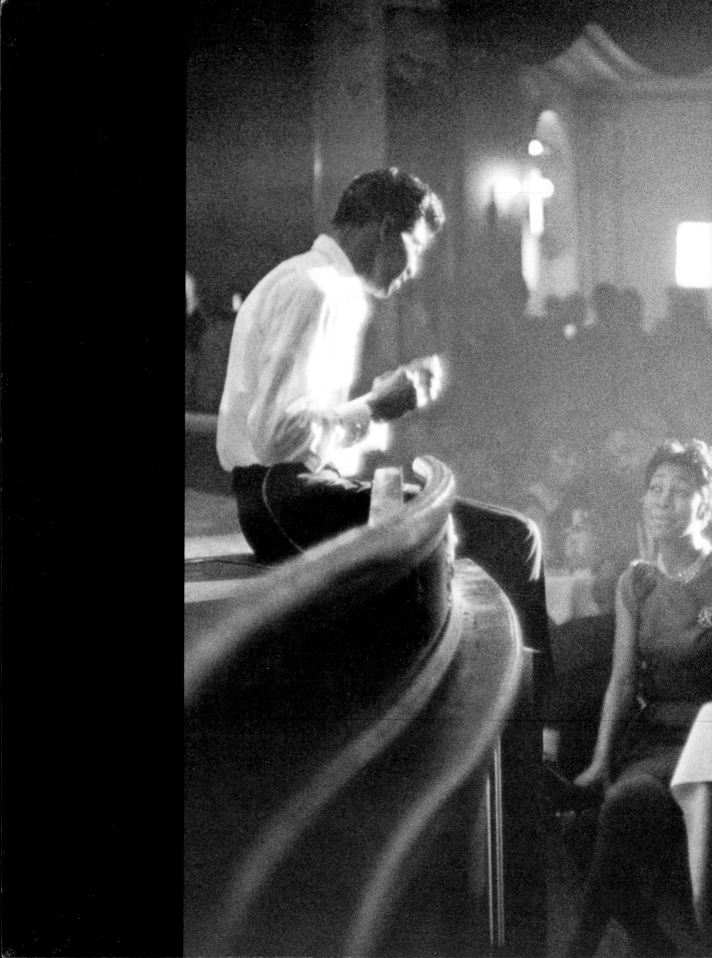

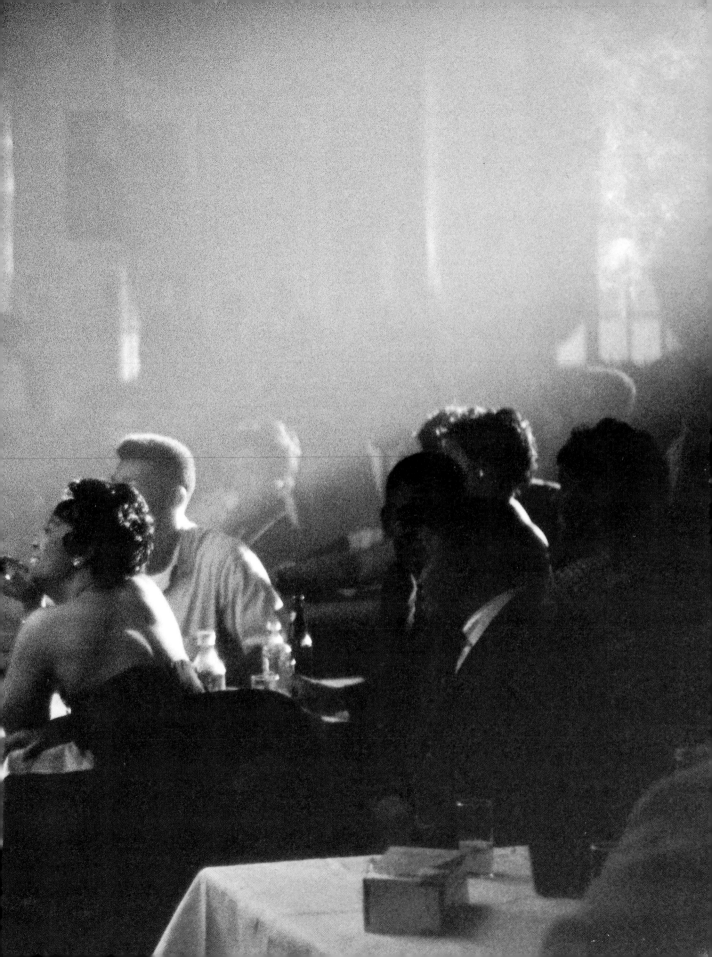

The Trianon Ballroom caught me by surprise. Spectacularly ornate, with vast reaches extending into high balconies and multiple stage settings, it was unlike anything I'd ever seen, certainly not like the little blues clubs that dotted the Southside.

The tremendous excitement generated in the massive crowds was different too. The electric shocks that coursed through your veins were immune to musical judgments.

Both Jackie Wilson and Bobby Blue Bland were past masters at *anti*-crowd control. They whipped those vast collections of their fans into a frenzy—sounded out in uncontrollable screams, exhortations and pleadings.

Bland reached the decorative sex in very basic ways, inspiring them to surge toward the stage in hopes of getting a touch, a vibration—a "vapor"—of their "love spokesman."

It was crazy and indescribably exciting!

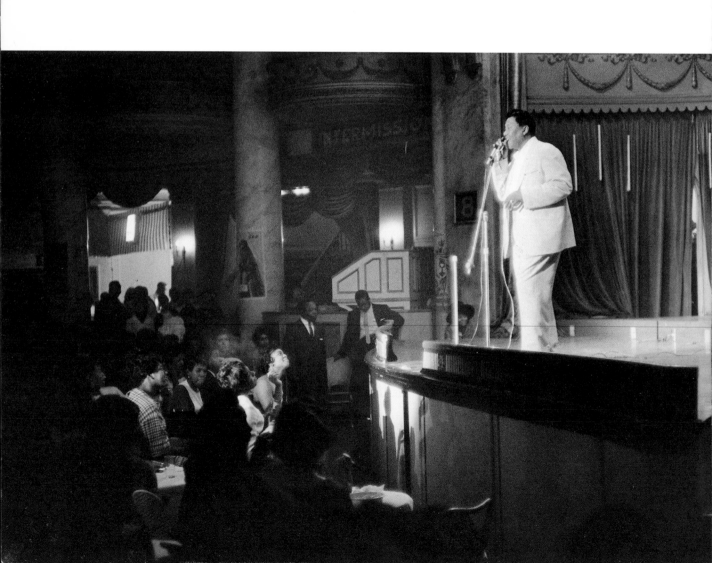

Bobby Bland 1963

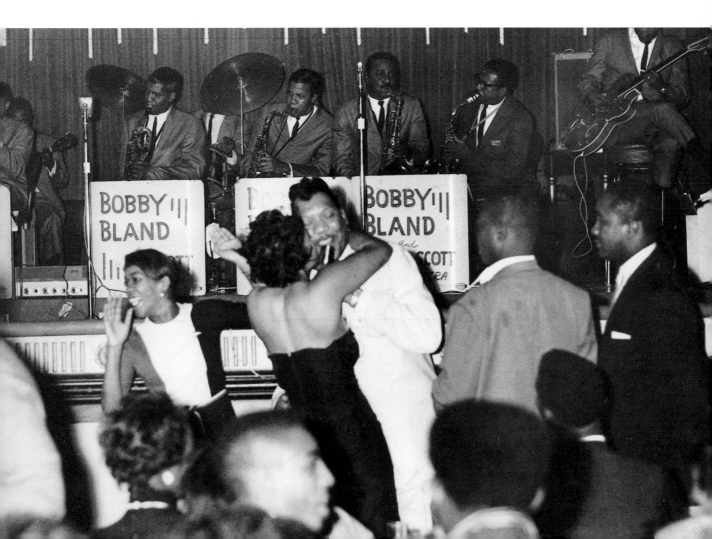

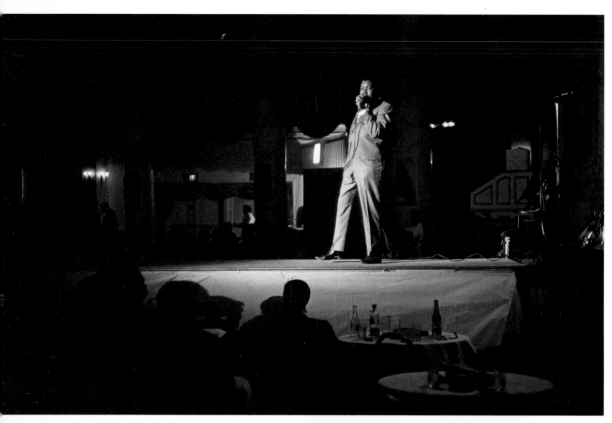

Junior Parker 1963

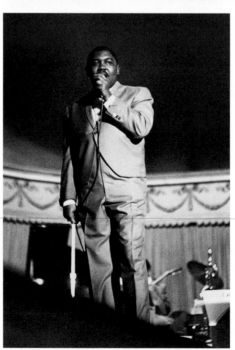

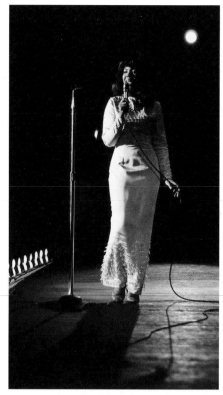

Mary Wells 1964

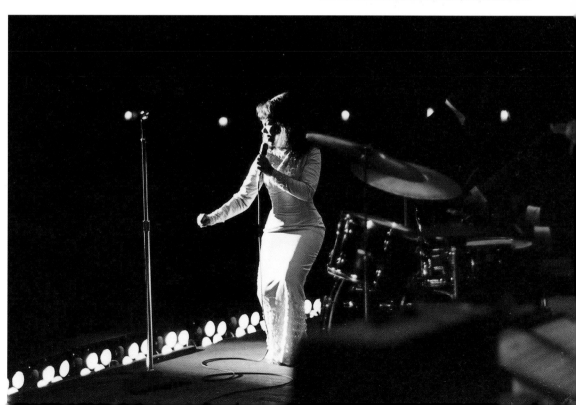

When Lloyd Price and Slide Hampton both started to gyrate on stage at the Trianon a little before Christmas in 1963, it seemed to me the limits of blues performance were starting to get stretched out of shape. A singer and an arranger *and* a *conductor?* Kind of large for a simple *blues!*

Fortunately nobody else tried to expand this bizarre concept. Some of them came close, but they never quite made it into a *Mahler Symphony* orchestra (or a "Symphony of a Thousand")!

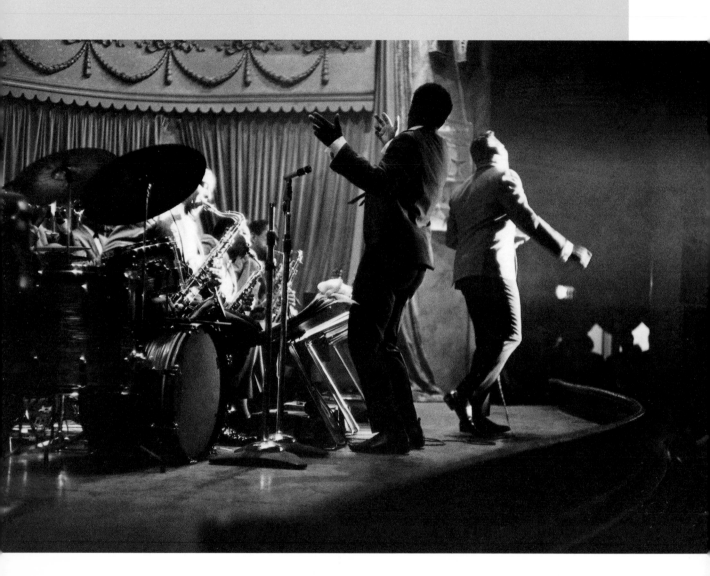

Lloyd Price and Slide Hampton Band 1963

Tommy Tucker 1963

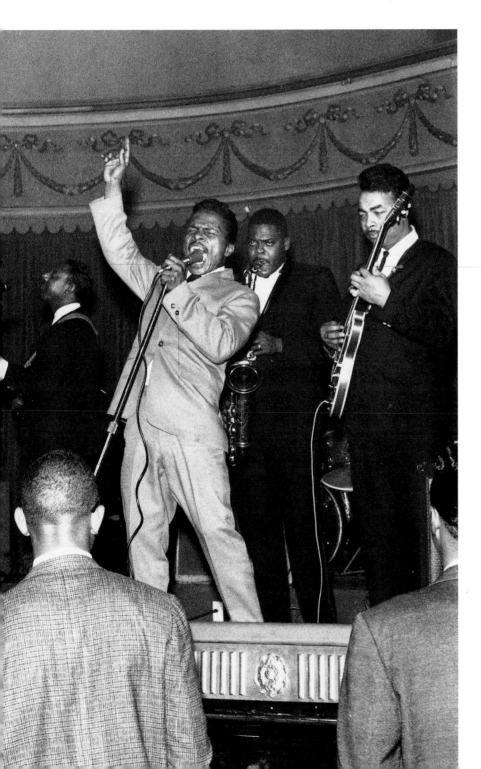

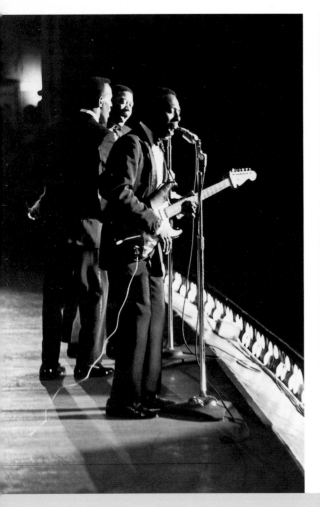 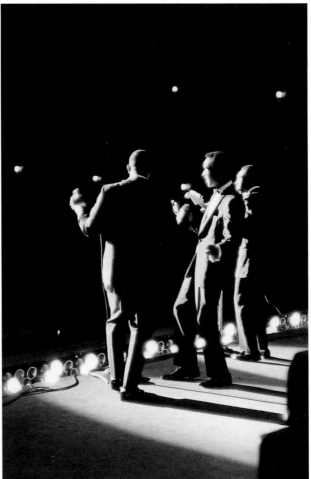

Curtis Mayfield, who led The Impressions in such contrasting hits as "For Your Precious Love" and "People Get Ready," taught himself a highly individual style of guitar picking to lift himself out of Chicago's notorious Cabrini-Green housing project. His songs set a new direction for R&B, addressing both civil rights and religious themes. Injured in 1990 by falling equipment in a stage accident, Mayfield remained paralyzed and in poor health until his death in 1999, a few days short of the Millennium celebrations.

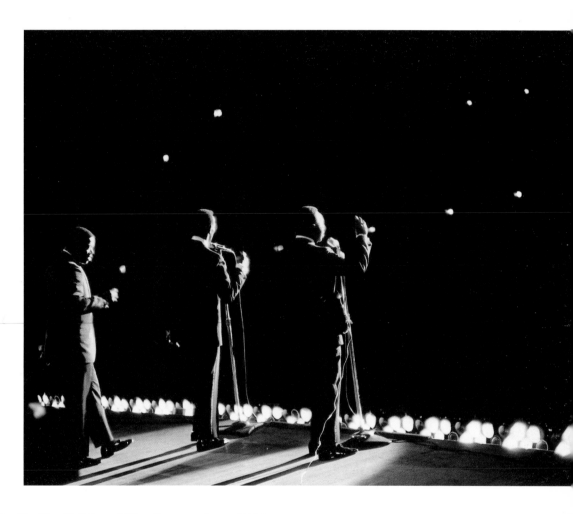

Curtis Mayfield and The Impressions 1964

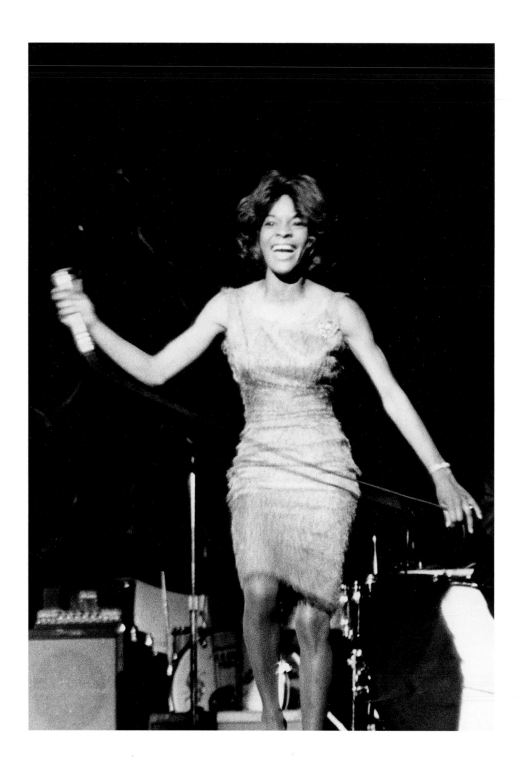

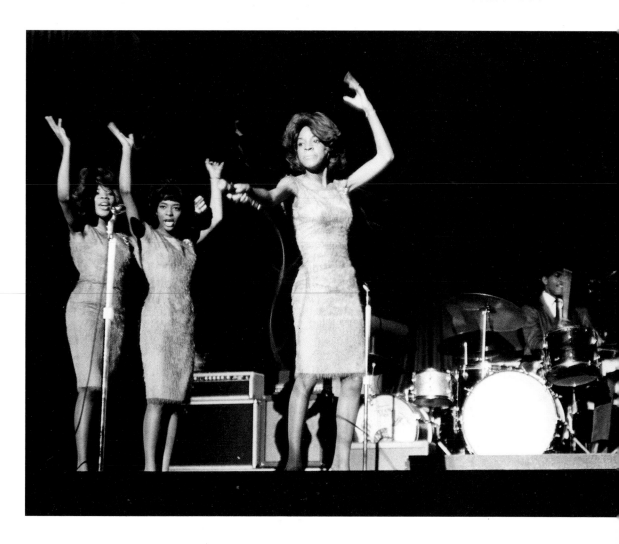

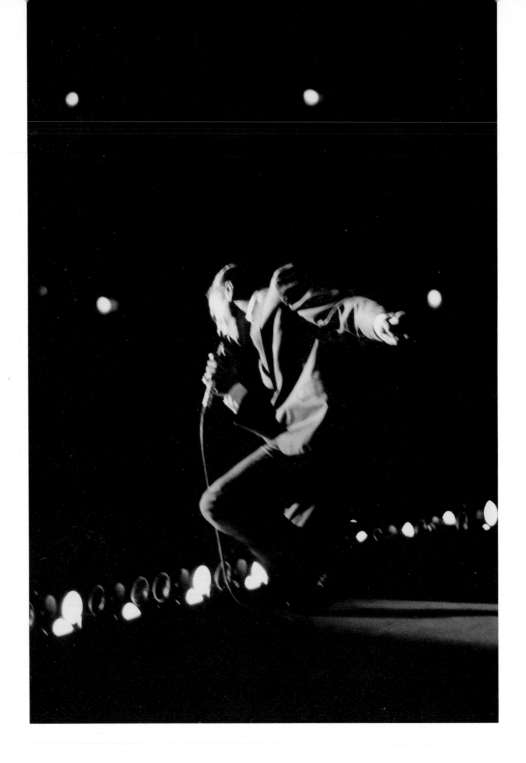

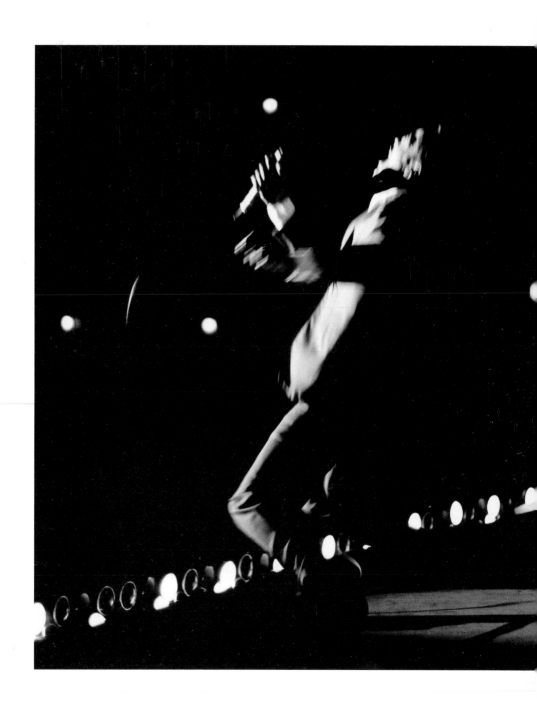

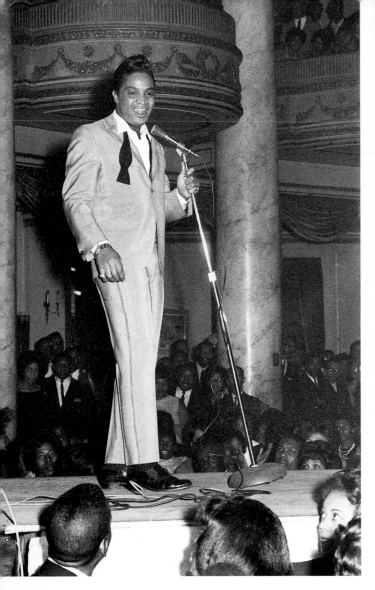
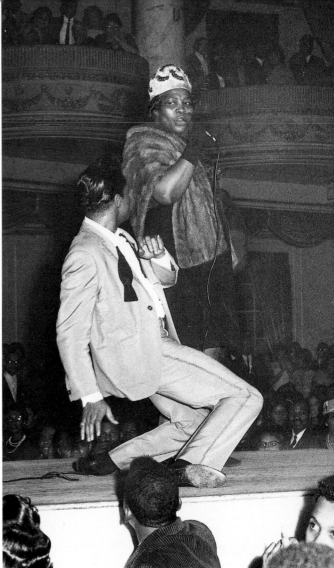

It was early 1964. Jackie Wilson had drawn an overflow crowd to the Trianon Ballroom. They came to hear his bittersweet songs of love and loss, and to watch him dance and prance across the stage, to make the moves that reminded you he once aspired to be a boxer.

Three years before he had been shot by a jealous woman. Now fully recovered, he was at the top of his game. Tonight, well past 1:00 AM, the smoke was getting denser and the crowd was getting restless. He probably was waiting for that exact moment. When Jackie finally strutted onto the stage and began "Reet Petite," the crowd screamed crazily.

He was repeatedly dragged off the stage by his fans and pulled back as often by his "security guards," before dropping to his knees in choreographed "rapture." It was an exhilarating and unforgettable performance.

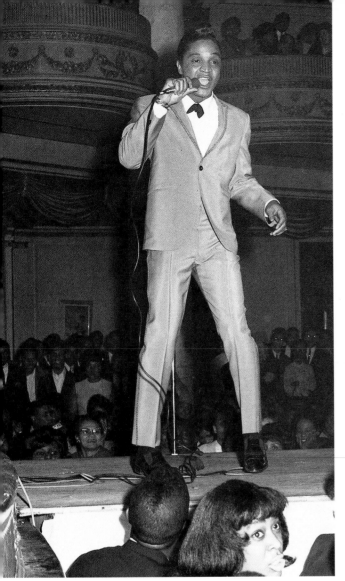
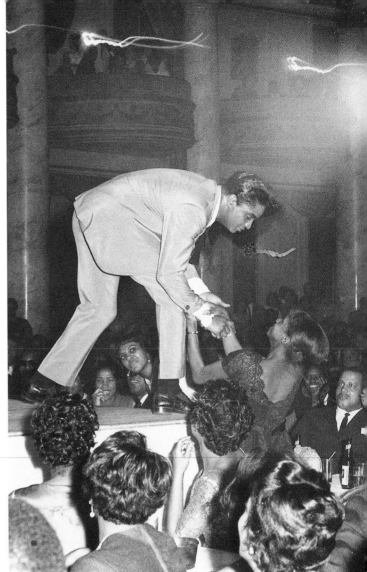

Jackie Wilson 1964

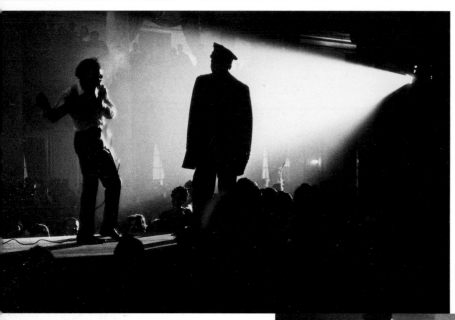

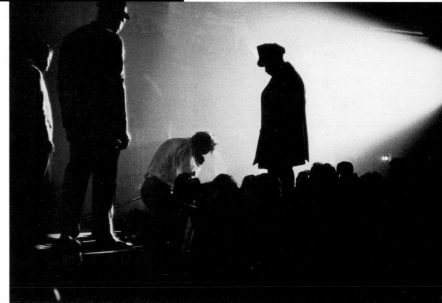

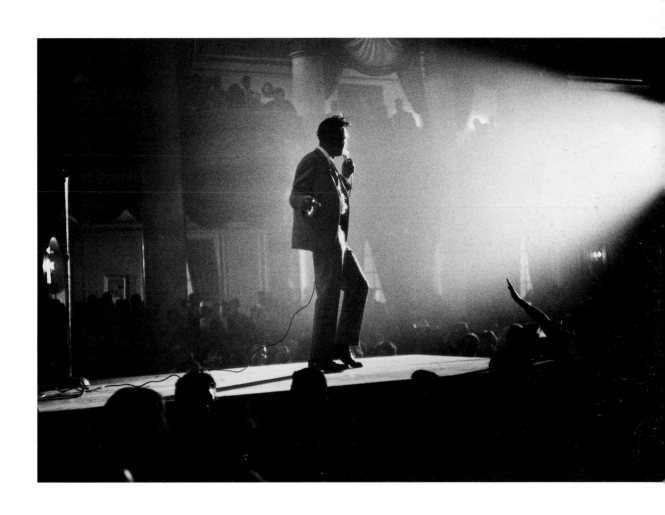

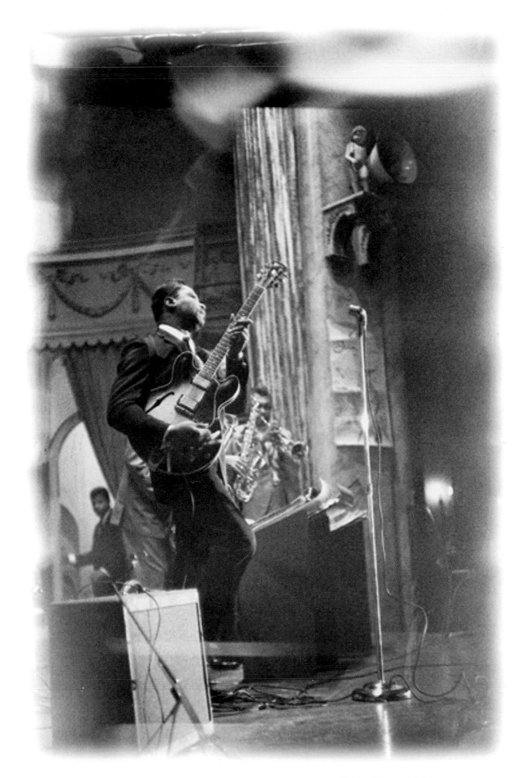

B.B. King 1963

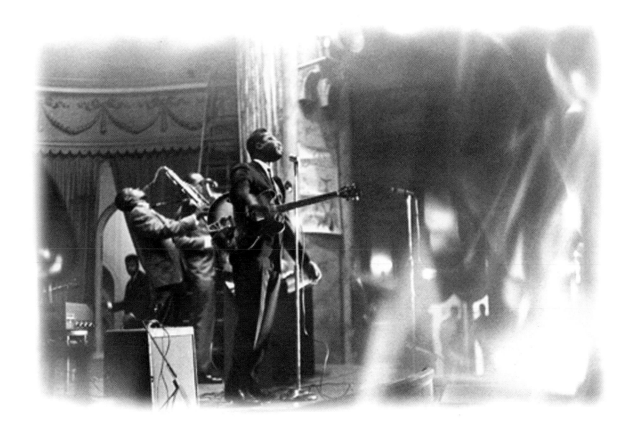

When *Rhythm & Blues* magazine asked me to cover B.B. King's appearance at the Trianon, I was looking forward to meeting him—the most articulate of the blues giants and a former DJ like myself. We might have had good stories to swap. But it didn't happen. Although I had my press pass, it wasn't shown to the stage hands who hovered around as though they were afraid I'd run out on the stage flashing away. So I was limited to "grab shots"—mostly from the wings. The result was that although there were many good shots from unusual angles, funny things happened with the lighting. Some people like them, but they're kind of odd. At any rate, you don't often see him from the angles you see him from here....

The best known photograph, in which his face and hands are blurred, resulted from a darkroom accident. The film was lightstruck and it looked like the whole roll was ruined, but I had a deadline to meet so I stayed up all night pouring over the proof sheets. Finally, I found a piece of shot that would work. It became one of my most successful images.

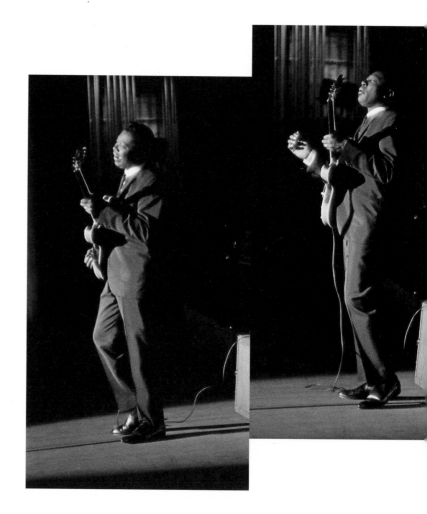

B.B. King 1964

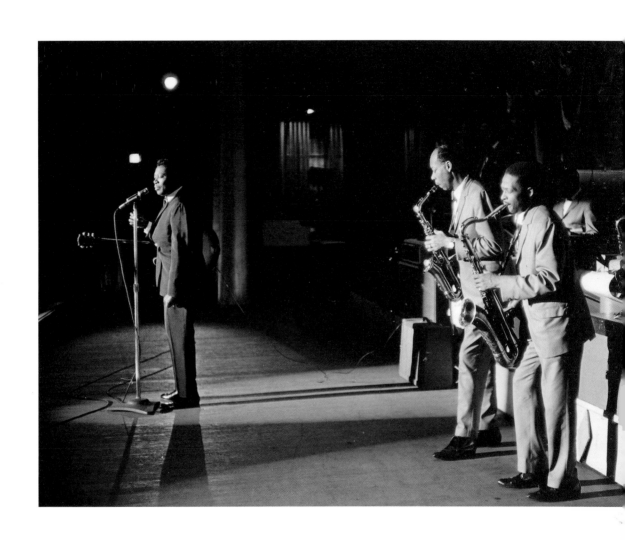

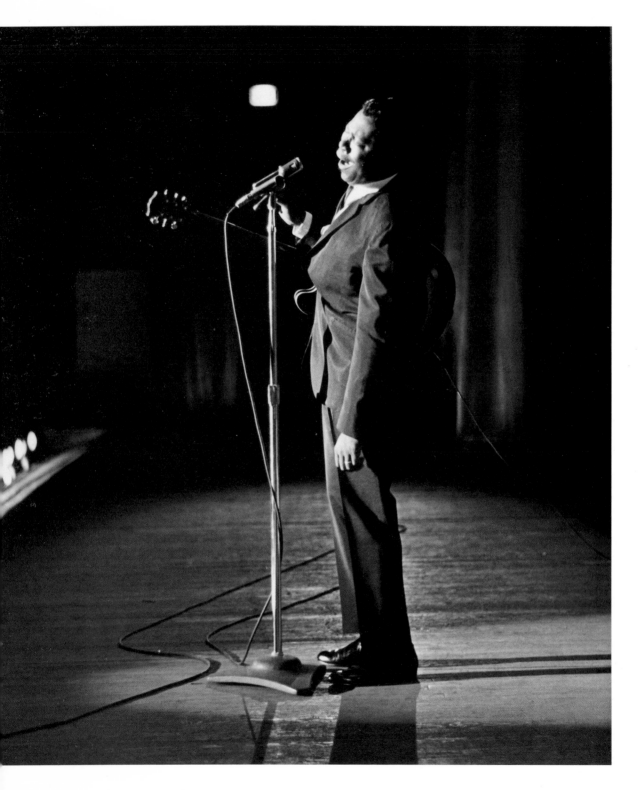

B.B. King 1964

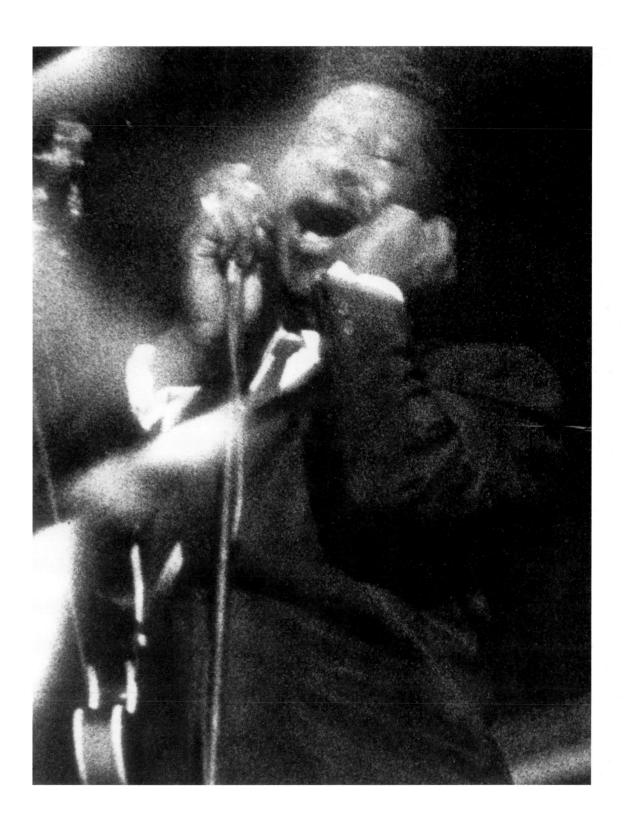

Page ii-iii: The Trianon Ballroom audience, Bobby Bland show, 1963.

Page vi: Carl Sandburg, book signing at Kroch's and Brentano's, 1961. I helped Kroch's and Brentano's open their folk record department.

Page xi: Shuttered business, Near North Side, 1960. After covering an art fair I stumbled into this scene.

Page xiii: Interview shot taken of me by Peter Amft, 1995.

Page xiv: Moe Asch by candlelight, 1959.

Page xv: Lyon & Healy store window, Chicago, 1962; Moe Asch, 1960.

Page xvii: Ray behind the cameras, shot by Stan Shapin at the University of Chicago, 1961; at WXFM radio station, taken by the engineer, Al Urbanski, 1960.

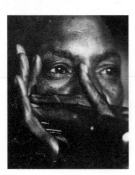

Page xxii-xxiii: Southside Chicago streets, early 60's.

Page 2-3: Southside grocery store taken for Prestige Records album cover, 1965.

Page 4-7: Basement tryouts, Southside, 1963.

Page 8: Mike Bloomfield, during an art fair, Near North Side, 1960.

Page 10: Southside street, early 60's.

Page 11: This was my first assignment with Big Joe Williams for his Folkways LP. Shot on his porch, Southside, 1962.

Page 15: Otis Spann and James Cotton rehearsing in Muddy Waters' basement, 1965. Although recognized worldwide as one of the greatest pianists in the history of the blues, Spann remained totally unassuming in manner. When he played his long sustained blues solos, he achieved a kind of profundity that lingered in the memory. Otis Spann is my No. 1 blues sound.

Page 18: Willie Dixon, Delmark recording session of Big Boy Crudup, June, 1968.

Page 19: Jimmy Dawkins, Lurrie Bell, Carey Bell. Delmark recording session, 1968.

Page 20: Lafayette Leake, 1970. Leake was a superb blues pianist whose career suffered from his reluctance to travel. His "Slow Leake" is a blues classic.

Page 21: left, Eddie Shaw; right, Robert Lockwood, Jr., 1970.

"Robert Junior" Lockwood is one of the great survivors, and one of the most important historical figures in the blues. Taught by the legendary Robert Johnson, his stepfather, Lockwood ran with Johnny Shines and other blues pioneers in the South, and has recorded with most of the blues "greats" in Chicago and other cities in the North: Roosevelt Sykes, Sonny Boy Williamson and dozens of others.

The "look of recognition" he gave me the first time I saw him will always puzzle me. Did he realize we were exact contemporaries?

Page 22: Art Hodes, 1970. Art Hodes had one of the most active recording careers of any jazz pianist in the business. From as far back as his Blue Note sessions in the Early 40's, Art played with most of the great names among the traditionalists—Barney Bigard, Albert Nicholas, Sidney Bechet, Mezz Mezzrow...an actual encyclopedia of great jazzmen.

Page 23: Fred Below, Delmark recording session, 1970. You could probably call Fred Below one of the great *insider's* bluesmen. A 1995 book on the blues *(The History of the Blues;* by Francis Davis) is dedicated "to Fred Below, the secret architect of rock 'n' roll." Below developed a completely original accompaniment style that changed the sound of Chicago blues.

Page 24: Top, Eddie Shaw on the left and Mighty Joe Young on the right; bottom, Roosevelt Sykes, 1970.

Page 25: Listening to playback—Roosevelt Sykes, Fred Below, Bob Koester. Delmark, 1970.

Page 27-29: Magic Sam, 1968.

Page 31: Left to right, Hammie Nixon,

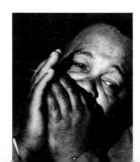

Sleepy John Estes, Mike Bloomfield, Yank Rachell, 1963. When this image was first used they "edited" out Mike. Later, after he became famous, he was added back.

Page 32: It's hard to believe—astonishing, really—that I didn't make the connection for 50 years! In 1946 I was giving lectures on the blues and was involved with theater people. In 1963 I was photographing Muddy Waters at 4339 S. Lake Park Ave., where he lived. The strange thing is that my 1946 address had been less than a mile away from Muddy— 3765 South Lake Park! *And I didn't make the connection!!!* The long span of years, the vast changes in my life, may account for the "mental lapse." The neighborhood now looked different and my persona was now different. (In 1946, I'd been forced to resort to "reverse passing" to get an apartment.) Now I was an acknowledged "Whitey" living in the Black community. Reminiscent of Schubert's *Doppelganger* I was reluctantly "looking visually" at my own lost past.... Did I mention that Muddy and I were born the same year, thousands of miles apart? Now the years had brought us *together.*

Page 33: Mike Bloomfield interviewing Muddy. The sweet little girl is Muddy's granddaughter, Cookie.

Page 34: Left to right, unknown, unknown, Mike Bloomfield, John Lee Hooker (with his back to the camera), Pete Welding, 1964.

Page 36-37: John Lee Hooker, 1964.

Page 40-41: Howlin' Wolf at Mr. Lee's Lounge, 1962.

Page 42: Mike Bloomfield interviews Wolf while Sumlin looks on.

Page 45: Hubert Sumlin, lead guitar; Johnny Jones, piano; Willie Young, tenor; Andrew "Blue Blood" McMahon, Kay-bass; Cassell Burrow, drums.

It was a shock to realize how powerful was Hubert Sumlin's contribution to the Howlin' Wolf sound. He was the key player, and yet his manner was so diffident, so retiring, so "subordinated" that he could have passed for the errand boy.

Page 46-49: The Howlin' Wolf Band at Sylvio's, 1964.

Page 50-51: Exterior of Pepper's Lounge, 1963.

Page 52: Top, Otis Rush performs at Pepper's Lounge; middle, left to right, "Memphis Charlie" Musselwhite, Mike Bloomfield, unknown, Paul Butterfield; bottom, interior Pepper's Lounge, 1963.

Mike Bloomfield haunted the blues clubs—especially Pepper's, where he dug Otis Rush "the most." Sometimes I'd carry him there on my photo sessions, sometimes I'd just run into him with Paul Butterfield and "Memphis Charlie" Musselwhite, sitting at "ringside," absorbing the powerful soul sound of the blues, that they would later project on their own. The Black blues masters were very generous. They regularly helped their potential rivals develop their own chops.

Page 53: Otis Rush performs at Pepper's, 1963. Mary, the waitress Charlie mentions in the text on page 52, is on the right side with Charlie just in front of her.

Page 54: Otis Rush, Little Bobby on sax. Pepper's, 1963.

Page 55: Jr. Wells performing at Theresa's, 1965.

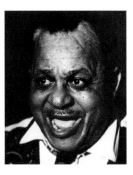

Page 56: On the bottom right, Bob Koester (owner of the internationally famous Jazz Record Mart, as well as Delmark Records), and his guests with Theresa Needham (owner of Theresa's Lounge) standing on the right.

Page 57: Jr. Wells, Theresa's, 1965.

Page 58: Lightnin' Hopkins, Western Hall, 1965.

Page 59: Fans have named this shot "The Dixie Cups." The girls pictured here were at Lightnin' Hopkins' performance at Western Hall. What a contrast—beer in Dixie cups and chiffon dresses! 1965.

Page 60: Top, Billy Boy Arnold; middle left, John Littlejohn; middle right, Howlin' Wolf, 1964-68.

Page 61: Magic Sam at the 1815 Club, 1968.

Luise and I still "hurt" when we think of Magic Sam. He was a real "sweetheart."

The cold winter night in 1968 when we shot him at the 1815 Club, Sam left the bandstand when he saw we were leaving, and without throwing on a coat or jacket, ignoring the potential effect on his fine, Italian shoes, he led us across the median strip to our car on the other side, wading through the ankle-deep snow in spite of our protest. He wanted to be sure we were safe.

Page 63: Memphis Slim's spidery fingers. This shot is from the second photo session I did with Slim for Folkways Records. It is one of the most widely used of my images.

Page 66: Big Joe Williams; in the background Mike Bloomfield is playing bass. Folklife Festival, University of Chicago, 1962.

Page 67: Big Joe Williams, Folklife Festival, 1961.

Page 68: Sunnyland Slim, Folklife Festival, 1962.

Page 69: Left to right, Big Walter Horton, Floyd Jones, Sunnyland Slim, Big Joe Williams. Four of the great Chicago Blues Legends arrive at the University of Chicago's Mandel Hall for their 1962 Folklore Society Concerts. Under Sunnyland Slim's protective arms, Big Walter Horton and Floyd Jones (to his left) and Big Joe Williams (to his right) evoke the memory of the phrase, "The camaraderie of the blues."

Sunnyland fulfilled the role of *pater familias*.

Page 70: Ransom Knowling, Folklife Festival, 1962.

Page 71: Albert Nicholas, Sloppy Joe's, 1963. Art Hodes was the pianist.

Page 72: Little Brother Montgomery, Folkways "Church Songs" recording session, 1962.

Page 73: Little Brother Montgomery, Gate of Horn, 1960.

Page 74: Maxwell Street Jimmy, Testament Records, 1965.

Page 75: Big Joe Williams warming up backstage before a performance at University of Chicago, 1962. Editor Lisa Day discovered this shot while rummaging through my neglected proof sheets.

Page 76-78: Son House, 1964.

Page 79: Floyd Jones, Big Walter Horton and Sunnyland Slim perform at University of Chicago, 1962.

Page 80-81: Jazz Gillum, 1962. After the photo session I interviewed Gillum at my apartment. He made himself so much at home that he was still there 9 hours later.

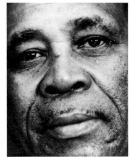

Page 84: Odetta, Gate of Horn, 1959. Many viewers are uncomfortable with the pronounced grain in the Odetta prints. Actually I found it necessary to "print for grain" after all-night attempts to achieve *"invisible-grain"* prints failed, resulting only in "muddy" and unattractive sheets of printing paper. In the end I found the emphasized grain exciting and I still prefer it in such images as this. But it loses me some jobs.

Page 85: Robert Nighthawk with Little Walter in background, University of Chicago, 1964.

Page 86: St. Louis Jimmy, Fickle Pickle, 1963.

Page 87: Arvella Grey performing at an Ellla Jenkins autograph party, 1962.

Page 89: Mississippi Fred McDowell, 1966.

Page 90: Top, Mississippi John Hurt, Mandel Hall, University of Chicago, 1965; bottom, Robert Pete Williams, Folklife Festival, University of Chicago, 1965.

Page 91: Reverend Gary Davis, Ida Noyce Hall, University of Chicago, 1962.

Page 93-95: Furry Lewis, University of Chicago, 1964.

Page 97: Sonny Terry and Brownie McGhee, Institute of Design, 1966.

Page 98: Little Esther Phillips at an Atlantic Records reception to announce her latest LP release, 1970.

Page 99: Sleepy John Estes, 1963. This frequently reproduced "portrait" of Sleepy

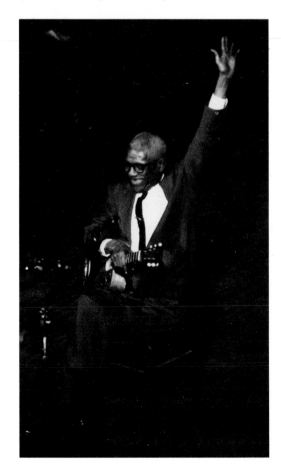

John Estes was only one of many of my photos appropriated without authorization for use as record covers, liner notes, etc. Others were Muddy Waters, Big Joe Williams and Memphis Slim. Oddly enough, one of the "borrowers" was one of my closest friends. That kind of theft seems to be a universal weakness.

Page 100: Elizabeth Cotten, University of Chicago, 1962.
Page 101: Josh White, Gate of Horn, 1962.

Page 102: Daddy Stovepipe, Fickle Pickle, 1963.

Page 103: Big Joe Williams and his Jug Busters, University of Chicago, 1964. From left to right, Sleepy John Estes, Yank Rachell, Big Joe, Hammie Nixon.

Page 104-105: Furry Lewis bottleneck guitar.

Page 106: Muddy Waters and James Cotton in performance at the Opera House, 1963.

Page 107: Muddy and James Cotton, Down Beat Jazz Festival, 1965.

Page 108: Muddy Waters and James Cotton, Opera House, 1963.

Page 109: Muddy with Mojo Buford in the background, Pepper's Lounge, 1961.

Page 110: Left to right, Al Grey, Dizzy Gillespie, James Moody, Muddy Waters, 1963.

Page 113: Jr. Wells, University of Chicago, 1966.

Page 114-116: Little Walter, 1966.

Page 117: Jimmy Reed, Trianon Ballroom, 1964.

Page 118-119: Buddy Guy, 1966.

Page 120-121: J.B. Hutto, 1966.

Page 122: Freddie King, Institute of Design, 1966.

Page 123: Freddie King, Ashland Auditorium, 1964.

Page 124: Johnny Shines, Western Hall, 1966.

Page 125: Joe Williams, Down Beat Jazz Festival, 1965.

Page 126-127: Al "TNT" Braggs, opening act for Bobby Bland at the Trianon Ballroom, 1963.

Page 128-129: Bobby Bland, Trianon Ballroom, 1963.

Page 131: Mary Wells, 1964. This was one of the most astounding shows at the Regal— Mary Wells, B.B. King, Martha and The Vandellas, The Impressions—all on the same night!

Page 133: Tommy Tucker, belting out "High Heeled Sneakers," 1963. When you hear other's rendition of his one massive hit you wonder how it fits into the blues, but when you hear Tucker's original recording with its very spare blues-y intro you realize where he's coming from.

Page 134-135: Curtis Mayfield and The Impressions, Regal Theater, 1964. For *Rhythm & Blues* magazine.
Page 136: Martha Reeves, 1964.

Page 138-139: Unidentified performer, Regal Theater, 1964.

Page 144-145: B.B. King, Trianon Ballroom, 1963.

Page 146-148: B.B. King, Regal Theatre, 1964.

Page 149: B.B. King, Trianon Ballroom, 1963.